Jean-Baptiste Greuze

The Laundress

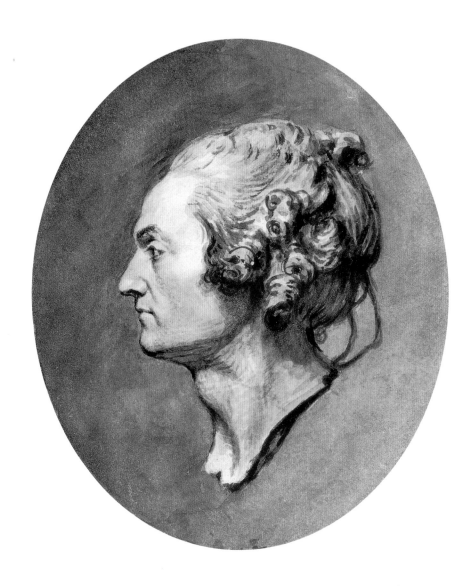

JEAN-BAPTISTE GREUZE

French, 1725–1805

Self-Portrait, circa 1763

Jean-Baptiste Greuze

The Laundress

Colin B. Bailey

GETTY MUSEUM STUDIES ON ART

Los Angeles

This book is dedicated to my mother, Hilda Bailey,
and to the memory of my father, Max Bailey.

Christopher Hudson, *Publisher*
Mark Greenberg, *Managing Editor*

Mollie Holtman, *Editor*
Jeffrey Cohen, *Designer*
Elizabeth Zozom, *Production Coordinator*
Jack Ross, *Photographer*

Library of Congress
Cataloging-in-Publication Data

Bailey, Colin B.
 Jean-Baptiste Greuze : The laundress /
Colin B. Bailey.
 p. cm.—(Getty Museum studies on art)
 Includes bibliographical references.
 ISBN 0-89236-564-1 (paper)
 1. Greuze, Jean-Baptiste, 1725-1805.
 Laundress (Getty Museum) 2. Laundresses
 in art. 3. Laundresses—France—Paris—
 History—18th century. 4. J. Paul Getty
 Museum. I. Greuze, Jean-Baptiste, 1725-
 1805. II. Title III. Series.
 ND553.G8 A69 2000
 759.4—dc21 99-056026

Cover:
Jean-Baptiste Greuze (French, 1725-1805),
The Laundress, 1761. Oil on canvas,
40.6 × 32.4 cm (16 × 12 ⅞ in.).
Los Angeles, J. Paul Getty Museum (83.PA.387).

Frontispiece:
Jean-Baptiste Greuze (French, 1725-1805),
Self-Portrait, circa 1763. Brush and india ink wash
on white paper, 15.7 × 13.5 cm (6 ⅛ × 5 ⅜ in.).
Oxford, Ashmolean Museum.

All translations are the author's,
unless otherwise stated.

All photographs are copyrighted by the issuing
institution, unless noted otherwise.

Typography by G & S Typesetters, Inc.
Austin, Texas
Printed in Hong Kong by Imago

Contents

Final page folds out, providing a reference color plate of *The Laundress*

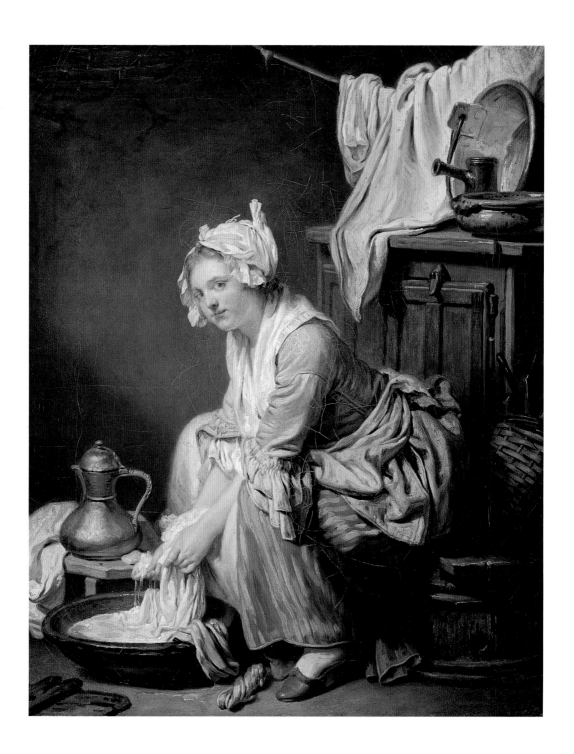

THE REDISCOVERY OF AN EIGHTEENTH-CENTURY FRENCH MASTERPIECE

Although Greuze's *La Blanchisseuse* (*The Laundress*) [FIGURE 1, FOLDOUT] was well received at the Salon of 1761—and, within the conventions of eighteenth-century journalistic art criticism, widely (and favorably) commented upon in the press—it has remained almost unknown in our century. Before its acquisition by the Getty Museum in 1983, the painting was reproduced only once, in black and white, in Lady Emilia Dilke's pioneering survey, *French Painters of the Eighteenth Century*, published in 1899. That it has taken a hundred years for Greuze's *Laundress* to receive the scholarly attention it deserves is due more to the accidents of provenance than to any willful art-historical neglect. As is explained in the text, from 1770 until 1983 Greuze's *Laundress* formed part of several distinguished Swedish private collections and was not available for easy scrutiny when, in the late 1960s, scholars such as Anita Brookner and Edgar Munhall began to rehabilitate the career of the largely discredited Greuze.

Exceptionally, therefore, we are in the position of having an eighteenth-century masterpiece, about which a great deal was already known, but which had "disappeared" from circulation until just over a decade ago. In the text that follows, I have profited from the recent renaissance in the study of Ancien Régime art and society—to mix art-historical metaphors—not only to situate this work in the context of Greuze's early career and to consider it against what is known of the realities of washing linen in eighteenth-century Paris, but also to suggest how

patronage, exhibiting, and marketing each played a significant role in *The Laundress*'s early history.

Art-historical precedents—contemporaneous, in the case of Chardin, old-masterish in the case of Dutch seventeenth-century cabinet painting—are discussed to show not only how indebted to traditional modes of representation is Greuze's lively interpretation of a servant washing linen, but also how original his interpretation is. An essential part of that orginality, it is argued, can be traced to the influence of popular culture, both literary and visual: thus does the regenerative energy of "popular, festive laughter"—to borrow Mikhail Bakhtin's phrase—once again inform art made within the hallowed precincts of the Academy's pedagogy.

Throughout this study, speculations on the various meanings or intentions of Greuze's painting have been grounded, wherever possible, in the evidence provided by eighteenth-century commentators. Here, we are lucky to be guided by the most perceptive and articulate art critic of the Ancien Régime, and one whose enthusiasm for Greuze—at least in the decade (1755-1765) that concerns us—makes him a particularly sympathetic *cicerone*. It seems fitting, then, to give Diderot the final word in this introduction: "Voici votre peintre et le mien" (Here is your painter and my very own).

GREUZE'S PATH TO THE SALON OF 1761

The sixth of nine children of Jean-Louis Greuze (1697-1769), a master roofer—the same profession as Jean-Antoine Watteau's father—and Claudine Roch, Greuze was born on August 21, 1725 in Tournus, near Mâcon, in Burgundy. His godfather was an associate of his father's in the building trade; his godmother, a baker's wife.[1] Although nothing is known of Greuze's upbringing or early formation, his family seems to have been industrious and reasonably prosperous; by the time of his marriage in February 1759, Greuze's father was listed in the documents as an architect.[2] His parents also seem to have been receptive to his desire to become a painter. As one of the younger children, Greuze was not obliged to follow in his father's profession, and he began his apprenticeship in Lyon with the leading portraitist of the city, Charles Grandon (circa 1691-1762).[3]

Around 1750 Greuze moved to Paris, where he refused to attach himself to an established master—Baron Grimm later noted that he was obliged "to paint small pictures to earn his daily bread"—but he nonetheless studied life drawing at the Academy, obliged to sit at the back of the class, far from the model, since he had none of the privileges conferred by institutional affiliation.[4] The history painter Charles Natoire (1700-1777), who had taught drawing to the young La Live de Jully (Greuze's future patron), was one of the professors who encouraged him, and through the support of the sculptor Jean-Baptiste Pigalle (1714-1785) and the painter Louis de Silvestre (1675-1762), who became Director of the Academy in July 1752, Greuze was invited to seek admission to that august institution.[5] On June 28, 1755, Greuze presented three works

in support of his candidacy—*A Father Reading the Bible to His Family* (Paris, private collection), *The Blindman Deceived* (Moscow, Pushkin Museum), and *The Sleeping Schoolboy* (Montpellier, Musée Fabre)—and was made an associate member as a *peintre de genre particulier*.[6] Along with his brilliant and incisive *Portrait of Louis de Silvestre* (Munich, Alte Pinakotech)—executed in public two years earlier to allay suspicions that Greuze was being assisted in his work—these rustic genre paintings, much indebted to the growing taste for Dutch cabinet pictures of the seventeenth century, were shown to an enthusiastic audience at the Salon of 1755.[7]

Following this maiden appearance at the Salon, Greuze was taken on a Grand Tour of Italy by Louis Gougenot, abbé de Chezal-Benoît (1719-1767), to whom he had probably been introduced by Pigalle: the abbé defrayed all the traveling expenses, Greuze's later claims to the contrary notwithstanding.[8] Aspiring genre painters did not compete for the Grand Prix that enabled gifted students to continue their training in Rome at the Academy's expense, since such opportunities were normally reserved for future practitioners of "la grande peinture"—history painters who treated allegory, religion, classical mythology, or subjects from ancient and modern history itself. Greuze's eagerness to travel in Italy and gain firsthand knowledge of its monuments and collections are suggestive, then, of his ambitions at this relatively early stage. P.-J. Mariette, who admired the artist but detested the man, noted that the Italian sojourn was of little use to Greuze and that it was inspired largely by his vanity; but this seems unduly cynical.[9] It was as true of Greuze, as it had been of Watteau, that he "conceived of his art more nobly than he practiced it."[10]

Thus, from October 1755 until April 1757, Greuze was able to follow a program normally available only to history painters. For the first eight months he accompanied Gougenot to Turin, Genoa, Parma, Modena, Bologna, Florence, and Naples (Gougenot was elected as an Honorary Member of the Academy in recognition of his generosity to Greuze). Arriving in January 1756 in Rome, where they were welcomed by Natoire (now the director of the French Academy) and the abbé Jean-Jacques

Barthélemy (the antiquary and correspondent of the all-powerful comte de Caylus), Gougenot and his traveling companion remained together for another four months.[11] Greuze was invited to return to Paris via Venice, but decided, not without a certain anguish, to let Gougenot return home without him.[12] In May 1756 Barthélemy informed Caylus that Greuze was staying in Rome not only for its views and ruins—which provided "des richesses piquantes pour ses compositions"—but also in order to study Raphael. "And who knows whether the contemplation of these paintings will not lead him to set his sights even higher."[13] Natoire was in agreement: Greuze had "considerable merit," he wrote to Marigny, and "might well raise his genre to a new level."[14]

Greuze remained in Rome until April 1757—it is unclear whether he also spent the "several months" in Venice that he had intended[15]—and for the last six months of his sojourn he was lodged at the Academy's quarters in the Palazzo Mancini (Marigny having specified that his room should have "the light that is necessary for his work").[16] The Italianate genre paintings on which he was employed by Gougenot—and which circulated in Paris even before their appearance at the Salon of 1757—impressed observers not only by their naturalism and local color, but, more importantly, by their considerable seriousness and ambition. In a thoughtful discussion of *The Broken Eggs* [FIGURE 2], Barthélemy had concluded that "the figure of the girl has so noble a pose that she could easily adorn a history painting."[17]

Thus, as an unofficial *pensionnaire* of the Academy, Greuze received the formation of a history painter—albeit on his own terms and while enjoying considerable independence. It was during this Roman sojourn that he also received a commission to paint two ovals for Madame de Pompadour [FIGURES 3, 4]—perversely, he would take more than four years to complete them—and his Italianate genre scenes caused something of a sensation upon his homecoming.[18] Greuze was determined to make a splash in Paris, Barthélemy informed Caylus, and his submissions to the Salons of 1757 and 1759 amply confirmed the abbé's predictions.[19]

In the decade to come, Greuze would continue to infuse his immaculately crafted genre paintings with a range of references and al-

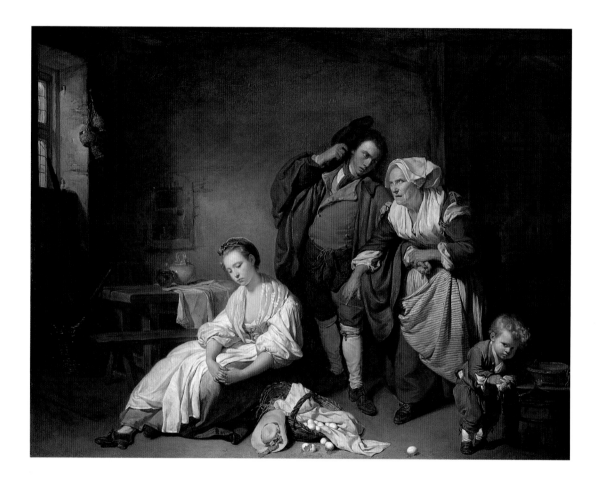

Figure 2
Jean-Baptiste Greuze,
The Broken Eggs, 1756.
Oil on canvas, 73 ×
94 cm (28¾ × 37 in.).
New York, The Metro-
politan Museum of Art
(20.155.8). Bequest
of William K. Vanderbilt,
1920.

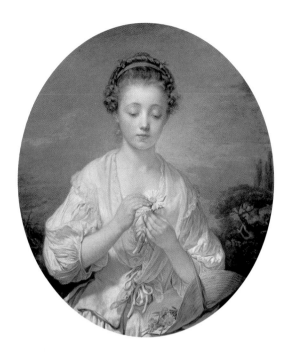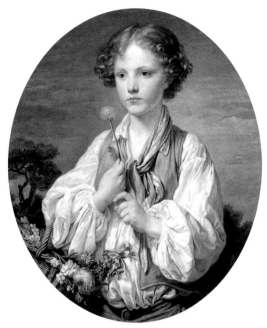

lusions well beyond his classification as a *peintre de genre particulier* (in this regard, Natoire's predictions proved accurate). In gesture, narration, and moral import, Greuze's most ambitious Salon submissions transformed the "bambochade" into didactic theater with an improving mission—Diderot's "peinture morale." Yet despite approval and recognition from critics, collectors, and the administration, Greuze—who, as Diderot observed, "had enormous presumption where his own talent was concerned"—could hardly have been expected to remain satisfied with the inferior status of "genre painter."[20] With a self-destructive streak that was entirely typical of the man, he would attempt to correct the Academy's misprision of his genius by submitting a *morceau de réception* in the category of history painting.

 All associate members of the Academy had to present a reception piece for full membership, normally within six months of being granted associate status. The minutes of the Academy for June 28, 1755 record that Greuze was "to go to the Director, who will inform him of what he is to do for his reception."[21] Twelve years passed with Greuze,

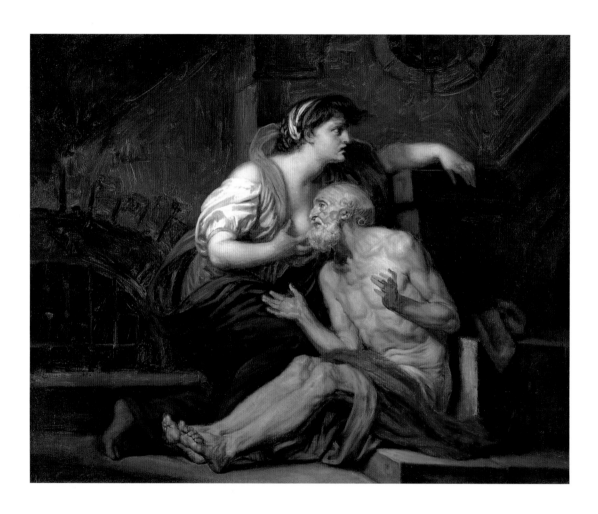

Figure 5
Jean-Baptiste Greuze, *Cimon and Pero: "Roman Charity,"* circa 1767. Oil on canvas, 62.9 × 79.4 cm (24¾ × 31¼ in.). Los Angeles, J. Paul Getty Museum (99.PA.24).

now one of the most successful and admired painters in Paris, having failed to upgrade his membership. In 1767, he was informed by Charles-Nicolas Cochin, Perpetual Secretary of the Academy, that he could no longer exhibit at the Salon until he had presented his *morceau de réception* (Diderot referred to Cochin's letter as "a model of decency and

8

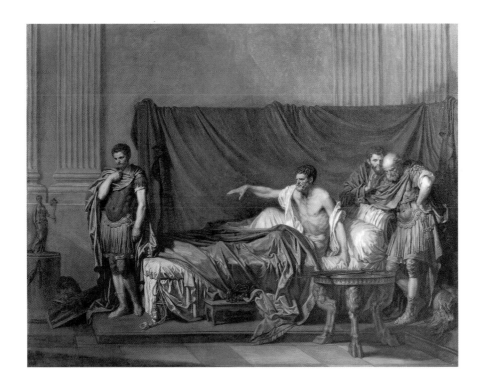

Figure 6
Jean-Baptiste Greuze,
*Septimus Severus
Reproaching Caracalla,*
1769. Oil on canvas,
124 × 160 cm
(48⅞ × 63 in.).
Paris, Musée
du Louvre (inv. 5031).

politeness").[22] Unable to exhibit at the Salon of 1767, Greuze set about preparing the long overdue reception piece—although it is most unlikely that he sought any direction from the Academy with regard to its subject—and, as Edgar Munhall has noted, between 1767 and 1769 he seems consciously to have experimented with an unusual variety of religious and historical themes (such as *Lot and His Daughters* [Paris, Musée de Louvre], *Aegina Visited by Jupiter* [New York, Metropolitan Museum of Art], *Cimon and Pero: "Roman Charity"* [FIGURE 5], and *The Death of Brutus* [Bayonne, Musée Bonnat], a subject suggested by Diderot himself).[23]

By the summer of 1767 Greuze had settled on an obscure episode that had taken place in Scotland in A.D. 210 and is recounted in Cassius Dio's *Roman History* (which he probably consulted in Pierre Le Pesant's translation of 1674). It is the moment when the Roman emperor Septimus Severus reproaches his son Caracalla, who has just failed in his attempt to assassinate him [FIGURE 6]:

9

If you wish to take my life, kill me now, for I am already old and no longer have my health. But if you are reluctant to strike this blow with your own hand, here is Papinian, Colonel of the Guards. Give him the task; whatever you command, he will obey, for you are now Emperor.[24]

This grandiose subject, more fitting for literary than pictorial interpretation—as several critics later observed—preoccupied Greuze for almost two years: in August 1767 Diderot praised his initial compositional sketch as highly promising.[25] Yet when this inflated and disjointed neo-Poussinist history painting was finally submitted to the Academy on July 23, 1769, the corporation showed its displeasure by agreeing to Greuze's election as a full member, but insisting that he be received "in the same category as his associateship," that is, as a genre painter.[26] It was a blow from which the artist would never entirely recover. After exhibiting at the Salon of 1769—where *Septimus Severus Reproaching Caracalla* was vilified by nearly all the critics—Greuze would boycott the Salon until 1800.[27]

THE LAUNDRESS MAKES A SPLASH

The Little Laundress *. . . is charming; but she's a rascal
I wouldn't trust an inch.* [28]

—DIDEROT, *Salon of 1761*

The embarrassing and distasteful spectacle of the Academy taking revenge on an unrepentant, if highly gifted, genre painter was many years in the future when Greuze exhibited *The Laundress* at the Salon of 1761. The little picture of a laundress wringing out her linen [FIGURE 1] was one of the fourteen works—paintings, drawings, and pastels—that he exhibited at the Salon of 1761; and despite its size, it caught the attention of all the critics. [29] Terse though their comments are, reviewers responded to the liveliness of the painting's color and handling, and to the ingratiating attitude of the figure itself—"a young laundress, who, as she bends over to wash her linen, casts a glance that is as flirtatious as it is cheeky." [30] The work was "precious . . . for its truth to life, its coloring, and the charm of its expression"; [31] through the artist's mastery of technique—a novel manner of applying impasto that was "his alone"—the flesh tones were rendered with transparency and softness; [32] Greuze had succeeded in achieving "the most beautiful finish, but without dryness." [33] Such was the care with which the critics scrutinized this picture, and so lifelike did they find the figure, that Diderot [FIGURE 7] chided Greuze for not placing the laundress more solidly on her wooden plank ("I'd be tempted to move that trestle forward just a little, so that she'd be seated more comfortably"), [34] while the abbé de La Garde, author of the widely read *Observations . . . sur les tableaux exposés au Salon*, took exception to the linen in the background, which detracted from the brightness of the laundress's cap ("the light there is too similar to that of her headwear"). [35]

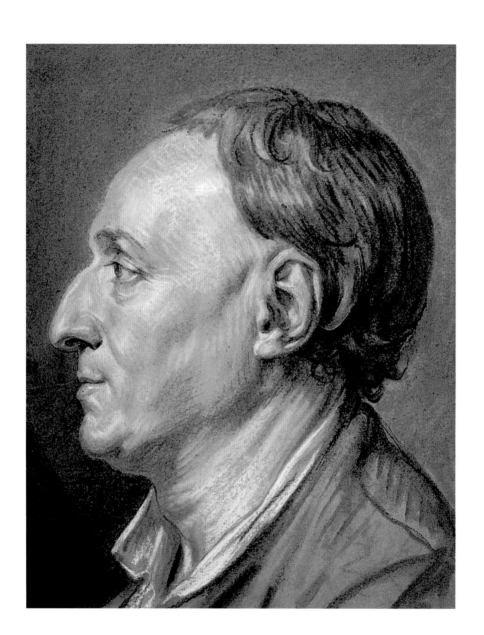

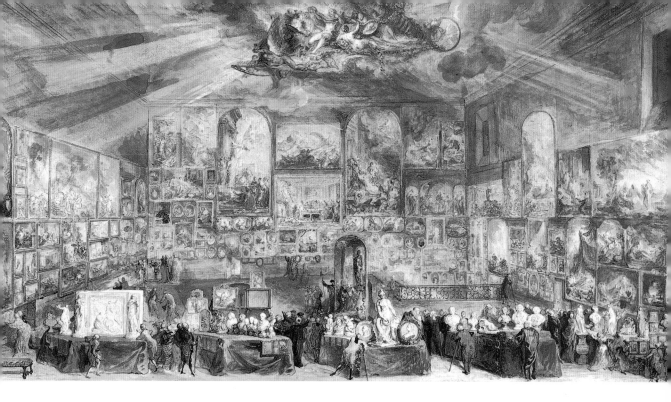

Although we do not know exactly where Greuze's *Laundress* was hung in the Salon *carré* of the Louvre—the cavernous gallery that was used for the Academy's biennial exhibitions of contemporary art [FIG-URE 8]—it can be assumed, from the exposure it received in the press, that it was placed sympathetically. Just one month before the opening of the Salon, the Ministry of Fine Arts had appointed Jean-Siméon Chardin, Treasurer of the Academy, to the post of *tapissier*, responsible for installing the two hundred or so entries. Chardin, the Minister was assured, "would accommodate the claims of seniority within the Academy, of which Artists are jealous, without prejudicing the pleasing harmony of the installation." [36] At first glance, the thirty-six-year-old Greuze [FRONTISPIECE], still an associate member (*agréé*) of the Academy, might not have been expected to receive much in the way of special treatment. Yet Chardin, with whom the much younger artist had been publicly compared at the Salon of 1757, was a firm believer in the newcomer's extraordinary talent as, it seems, was almost everyone else.

Figure 7
Jean-Baptiste Greuze (French, 1725–1805), *Portrait of Denis Diderot*, 1766. Black and white chalk on brown paper, 36.1 × 28.3 cm (14¼ × 11³⁄₁₆ in.). New York, Pierpont Morgan Library (1958.3). (Photo: Joseph Zehavi.)

Figure 8
Gabriel de Saint-Aubin (French, 1724–1780), *View of the Salon of 1767*, 1767. Pen and ink, watercolor, and gouache. Private collection, Paris. (Photo: Réunion des Musées Nationaux—Lagiewski.)

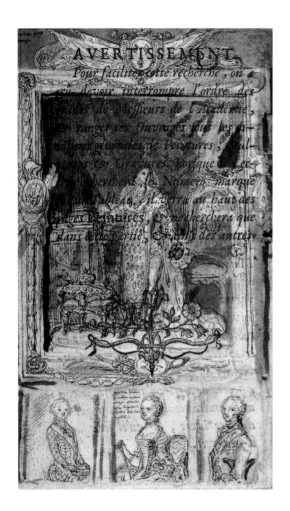

Figure 9
Gabriel de Saint-Aubin
(French, 1724–1780),
Illustration of "Avertis-
sement" from *Livret of
the Salon of 1761*,
p. 1. Paris, Bibliothèque
Nationale, Cabinet
des Estampes (Réserve,
Yd2 1132 rés.).

Another artist who paid heed to Greuze's appearance at the Sa-
lon of 1761 was the indefatigable flaneur and scribbler of genius, Gabriel
de Saint-Aubin, who illustrated eight of Greuze's entries and identified
the model for *The Laundress* as a *Mlle du Lieu* (The Miss of the Place)
in his Salon *livret* [FIGURE 9].[37] This generic name suggests that the young
woman was a professional model, probably well known to artists. As such,
her respectability would have been open to question, since, as Greuze's god-
daughter recalled many years later—and Diderot confirmed in his review of
the Salon of 1761[38]—it was customary for painters to employ as models only

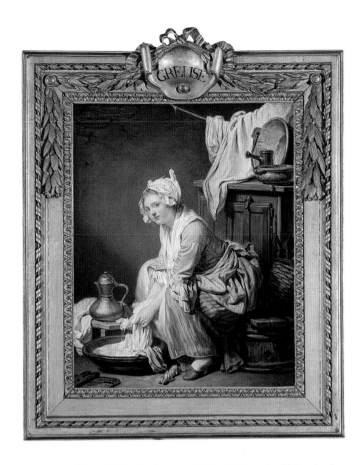

"such mercenary women, who sell their favors." For Mme de Valori, the artist had little choice in the matter. "How," she concludes, "could he have approached a woman of any decency?"[39]

Saint-Aubin's thumbnail illustration yields yet more information. Unlike his other sketches, that of Greuze's *Laundress* [FIGURE 10] includes the upper section of the frame, in the middle of which can be seen, quite distinctly, an elaborate cartouche. This detail provides a clue to the identity of the collector who lent Greuze's painting to the Salon of 1761—a collector who, while not listed in the *livret*, had already been mentioned by the fashionable *Mercure de France*.[40] La Live de Jully had been among the first to incorporate the artist's surname on the frames that he designed for his paintings, "because," as he himself noted, "it was perfectly possible to be a fine connoisseur and yet not know the artist's name" [FIGURE 11].[41]

Opposite right
Figure 10
Gabriel de Saint-Aubin
(French, 1724–1780),
Illustration of Greuze's
Blanchisseuse, from
*Livret of the Salon
of 1761*, p. 25 [detail].
Paris, Bibliothèque
Nationale, Cabinet des
Estampes (Réserve,
Yd2 1132).

Figure 11
Jean-Baptiste Greuze,
The Laundress, 1761
[with La Live de Jully
frame and cartouche].
Los Angeles,
J. Paul Getty Museum
(83.PA.387).

Third son of the immensely wealthy *fermier-général* Louis Denis de La Live de Bellegarde (1679-1751) and Marie-Josephe Prouveur de Preux (1697-1743), from old, but declining, military *noblesse* in the Hainault, Ange-Laurent de La Live de Jully (1725-1779) [FIGURE 12] was a pioneering collector of French painting and furniture who had been elected an *Associé-libre* (Honorary Member) of the Academy in June 1754, three months before his twenty-ninth birthday. Grimm gave him credit for discovering Greuze and organizing his admission to the Academy in June 1755, and of the four works that Greuze submitted in support of his candidacy, La Live immediately acquired three: these he lent to the Salon of 1755, Greuze's first public appearance in Paris.[42] Over the next decade, La Live de Jully went on to commission at least two portraits of himself from Greuze and to acquire

Figure 12
Jean-Baptiste Greuze, *Portrait of Ange-Laurent de La Live de Jully,* circa 1759. Oil on canvas, 117 × 88.5 cm (46 × 34⅞ in.). Washington, D.C., National Gallery of Art (1946.7 PA), Samuel H. Kress Collection.

Figure 13
Jean-Baptiste Greuze, *Portrait of the Dauphin Louis,* 1761. Oil on canvas, 72 × 58.7 cm (28 × 23⅛ in.). Private collection, New York.

17

Figure 14
Ange-Laurent de
La Live de Jully
(French, 1725–1779),
Standing Laundress,
after François Boucher.
Etching, 24.1 × 18.1 cm
(9½ × 7⅛ in.). Paris,
Musée du Louvre, Cabinet
des Dessins, Collection
Edmond de Rothschild
(inv. 18759; Jean-Richard
no. 1244).

another six genre paintings by him. Using his influence as *Introducteur des Ambassadeurs* (Head of Protocol) at Versailles, La Live de Jully also arranged for Greuze to paint the portraits of the dauphin Louis [FIGURE 13] and the dauphine Marie-Louise de Saxe, the former of which would be exhibited with *The Laundress* at the Salon of 1761.[43] Asked by the dauphine whether he enjoyed painting women's portraits, Greuze apparently replied that he did not care for "heavily made-up faces" (*les visages plâtrés*), at which point his royal sitter refused to have anything more to do with him. "You told me that the artist was a strange individual," the dauphin confided to La Live de Jully, "but you forgot to mention that he was a madman."[44]

Although La Live de Jully had himself engraved a country laundress after a drawing by Boucher [FIGURE 14],[45] it is unlikely that he had much to do with the choice of subject in Greuze's painting, let alone the manner in which it was executed.[46] Yet it is clear that *The Laundress* had been acquired (or commissioned) by him *before* its appearance at the Salon—and not afterwards, as had previously been thought[47]—and we also know, thanks to the dealer Pierre Remy, that Greuze was paid 600 livres for the painting, a figure in keeping with the going rate for cabinet pictures by Chardin and Boucher (artists at this stage a good deal more established than he).[48] Within a decade, the prices at which La Live de Jully acquired his Greuzes would seem meager. When his collection was sold at auction in May 1770—La Live de Jully, who had lost his mind, was now a ward of his wife—*The Laundress* fetched nearly four times its original price; it was purchased on behalf of a twenty-four-year-old Swedish nobleman, Count Gustaf Adolph Sparre (1746–1794), for 2,399 livres.[49]

While this might seem to confirm Diderot's observation that the opulent were interested in great artists primarily for the return on their investment, such cynicism would be inappropriate here. La Live de Jully's picture collection, a *cabinet historique* both encyclopedic and in-

clusive in character, had been assembled between 1752 and 1767 to offer a survey of French art from Poussin to Greuze. Motivated by "love of country" (*l'amour que j'ai pour ma Patrie*), La Live de Jully was the first collector systematically to represent each generation of French painters (and sculptors) from the foundation of the French Academy to the present day.[50] His "patriotic taste" (*goût patriotique*) was entirely in keeping with the cultural jingoism of the Encyclopedists; Diderot, for example, could claim without the slightest hesitation that "No one paints anymore in Flanders; there's hardly any painting done in Italy; only in France can it be said that the Art of Painting flourishes."[51]

Within La Live de Jully's "patriotic collection"—which filled seven ground-floor rooms of the *hôtel particulier* into which he and his new wife had moved in July 1762 [FIGURE 15]—Greuze enjoyed a certain prominence. *The Laundress* was hung in the Salon overlooking the garden (*Salon sur le Jardin*), where it presided over a cluster of small-scale cabinet pictures by Bertin [FIGURE 16], Lagrenée [FIGURE 42], and Drouais.[52] Thanks to the generosity of the proprietor, the collection was as well known

Figure 15
Garden Façade of La Live de Jully's Hôtel, rue de Ménard, Paris, circa 1762. Pen and ink, 44.7 × 33.5 cm (17⅝ × 13⅛ in.). (Photo: Christie's, London.)

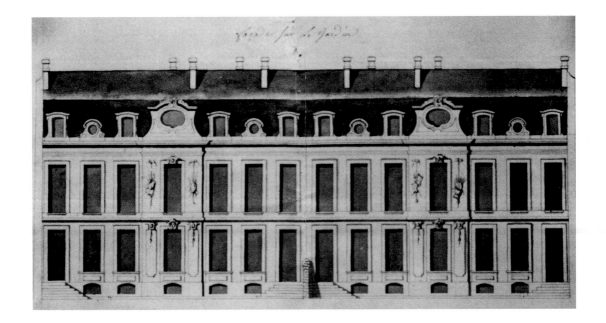

as any in Paris and available to a wide range of art lovers—from connois-seurs such as Horace Walpole (who thought little of the French paintings),[53] to the engraver, and Greuze's good friend, Johann-Georg Wille, who visited La Live's *cabinet* on July 22, 1762 in the company of a lawyer from Hamburg and a German language teacher.[54]

Unlike certain collectors, La Live de Jully was also more than happy to have his paintings engraved, so long as some reference was made to his patriotic enterprise. Greuze, who, in partnership with his wife, controlled every aspect of the reproduction of his paintings—from hir-ing the engravers to advertising the prints in the Parisian press—con-fided the job of reproducing *The Laundress* to Jacques-Claude Danzel.[55] It is unlikely that the engraving of a single-figure composition would have taken more than a year to produce—unfortunately, no contract for the commission has survived—and the print was ready by December 1765.[56] It was Greuze's custom to provide his engravers with a highly finished drawing of the work they were to copy (occasionally, he might also lend

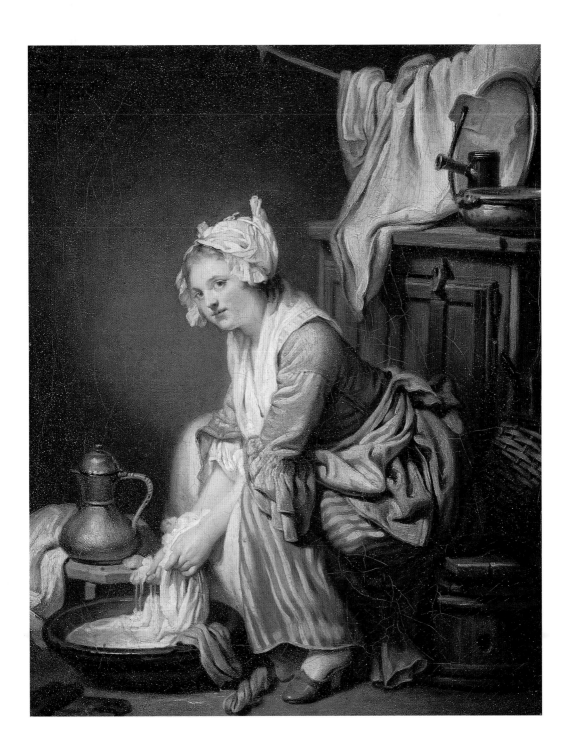

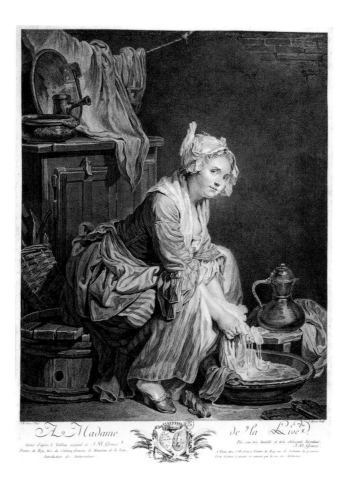

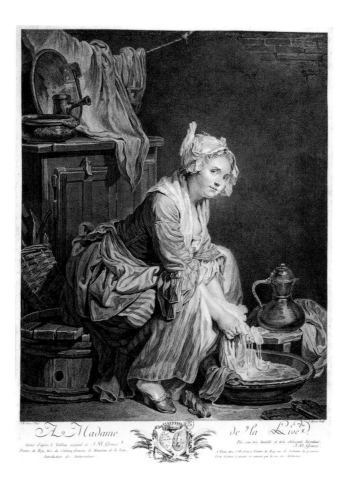

À Madame de la Live

Gravé d'après le Tableau original de J.B. Greuze Par son très humble et très obéissant Serviteur,
Peintre du Roy, tiré du Cabinet françois de Monsieur de la Live, J.B. Greuze.
Introducteur des Ambassadeurs. À Paris chés J.B. Greuze Peintre du Roy rue de Sorbonne la première
 Porte Cochere à main en entrant par la rue de Sorbonne.

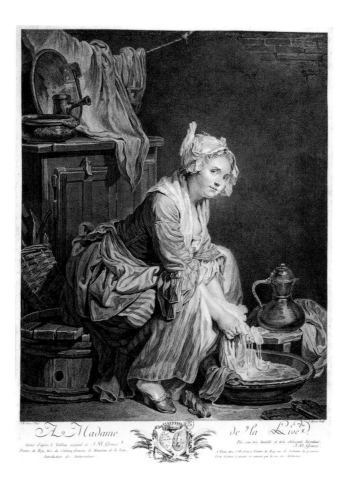

Figure 18
Jacques-Claude Danzel
(French, 1737–1809)
after Greuze,
The Laundress, 1765.
Engraving, 39 × 23 cm
(15⅜ × 9 in.).
Paris, Bibliothèque
Nationale, Cabinet des
Estampes (Dc 8, in fol.).

them the painting itself), yet the absence of any such drawing raises the possibility that the fine autograph replica of *The Laundress* [FIGURE 17], now in the Fogg Art Museum, may have been made to serve the engraver's needs.[57] Danzel's print was dedicated to La Live de Jully's wife and carried the obligatory inscription that the painting "was taken from the French collection (*Le Cabinet françois*) of Monsieur de La Live, Introducteur des Ambassadeurs" [FIGURE 18]. An announcement in the *Mercure de France* confirms Greuze's involvement in the marketing of these prints. Prospective purchasers were invited to buy Danzel's engraving directly from the artist himself, who conveniently provided directions to his house on the rue de Sorbonne.[58]

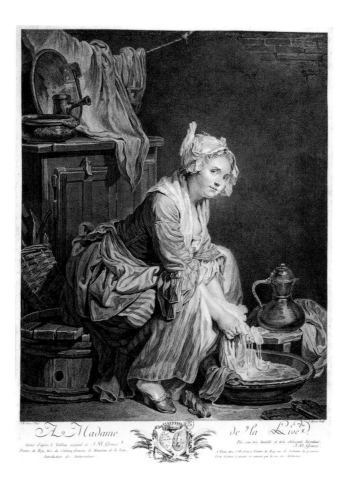

22

The Maidservant's Changing Role
in French Genre Painting

*I wonder if the head of the sister is not the same
as that of* The Laundress?[59]

—Diderot, *Salon of 1761*

A long with Greuze's other submissions to the Salon of 1761—which included portraits of himself, his wife of two years, and her father—*The Laundress* was soon overshadowed by his most ambitious narrative painting to date, *L'Accordée de village* (*The Marriage Contract*) [FIGURE 19]: "the painting that has *le tout Paris* returning to the Salon."[60] Commissioned by the marquis de Marigny, *Surintendant des Bâtiments* (Minister of Fine Arts) and younger brother of the King's mistress, Mme de Pompadour, *The Marriage Contract* finally made its way to the Salon on September 20, 1761, just over three weeks late, and the painting enjoyed a *succès d'estime* that would be equaled only by David's *Oath of the Horatii* a quarter of a century later.[61]

 The Marriage Contract's affective and dramatic unities satisfied the rampant sentimentality of the Parisian elites, while pictorializing many of the social concerns—population, the peasantry, the bonds of family—dear to Enlightenment thinkers. Its enormous appeal was due in part to the virtuosity and refinement with which it was painted, but even more to its wholehearted and reassuring commitment to an ideal, but not idealized, domesticity, one sufficiently rusticated for Parisian tastes (all happy families resembling one another as they are said to do). We witness the civil ceremony of a prosperous peasant marriage, with the earnest husband-to-be received into the bosom of his attractive wife's family through the exchange of the dowry and the notarizing of the contract. And the emotional force of

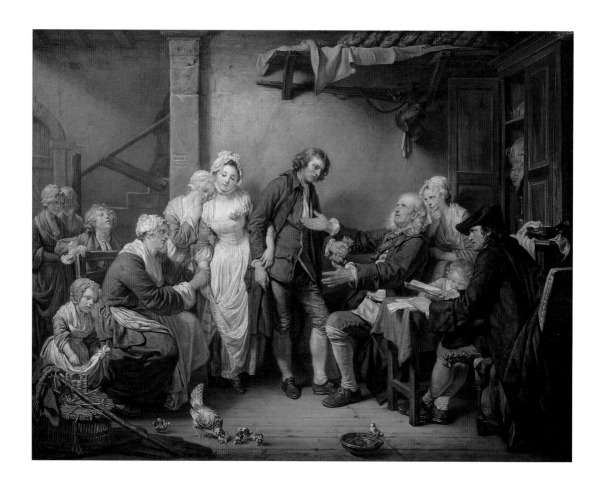

Figure 19
Jean-Baptiste Greuze,
The Marriage Contract,
1761. Oil on canvas,
92 × 117 cm (36¼ ×
46 in). Paris, Musée
du Louvre (inv. 5037).
(Photo: Réunion
des Musées Nationaux—
J. G. Berizzi.)

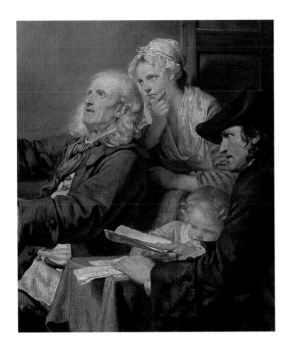

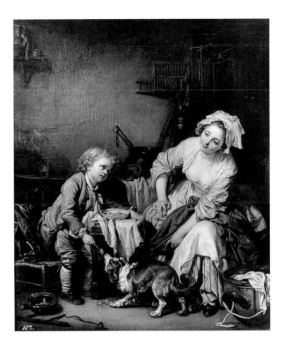

Greuze's domestic drama transforms a multifigured genre subject into history painting in the making. The stately, but harmonious, succession of generations is presented to the viewer in a crescent of sympathetically characterized figures, while at center, delicately illuminated, a mother hen and her brood discreetly symbolize the natural order.[62]

Greuze had been hard at work on *The Marriage Contract* since the middle of July at least,[63] and he most likely painted *The Laundress* around the same time. The laundress's red and yellow striped skirt is identical to the one worn by the demure wife-to-be, while her round cap, with its lappets covering the ears, is similar in design to the matriarch's headwear. Diderot felt, furthermore, that the model who posed for the jealous sister at right in *The Marriage Contract* [FIGURE 20] had also done duty as the figure in *The Laundress*. And so deep an impression did *The Laundress* leave on him that he did not hesitate, four years later, to identify the young mother in *The Spoiled Child* [FIGURE 21] as "that little laundress who has since married, and whose life [the painter] intends to follow."[64]

Figure 20
Jean-Baptiste Greuze,
The Marriage Contract
(see fig. 19), [detail].

Figure 21
Jean-Baptiste Greuze,
The Spoiled Child, 1765.
Oil on canvas, 66.5 ×
56 cm (26⅛ × 22 in.).
Saint Petersburg,
State Hermitage
Museum (inv. 5725).

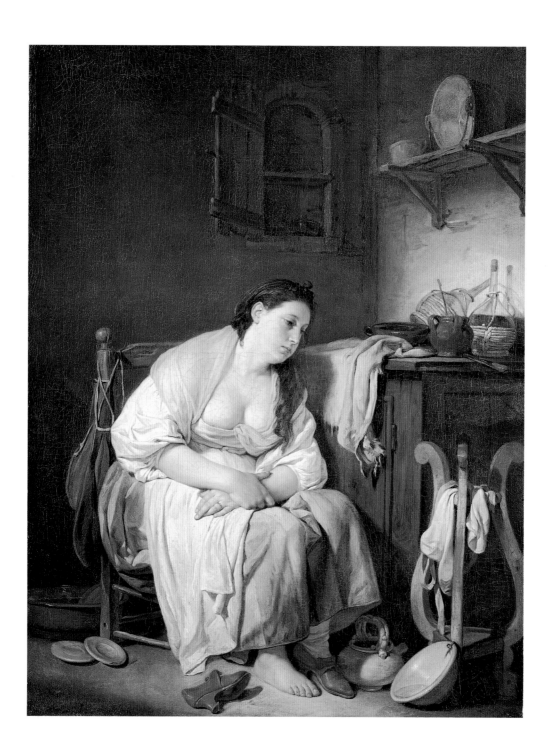

As Diderot and his fellow critics recognized, there was a strong family resemblance in Greuze's feminized *theatrum mundi*—a theater more interested in the world of "downstairs" than with urbanity or fashion, and one whose stage consisted of shabby garrets, untidy servant's quarters, or (at its most opulent) sparely furnished, rustic living rooms. In the decade following his admission to the Academy, Greuze's vigorous naturalism was not only selective, it was artfully constructed, self-referential, and occasionally erotic (the artist has more in common with Boucher than Diderot cared to admit). Yet Greuze's "realism" and "morality" were also welcomed as an antidote to the "decadence" of Boucher's pastorals, and his method of working directly from the model commended as part of a larger commitment to "truthful painting." [65] Here is Diderot:

> He is incessantly making studies; he cares not how much effort or expense it costs to have the right models He is constantly observing the world around him, in the streets, at church, in the marketplace, in the theater, on walks, in public assemblies. [66]

The pictures themselves tell a rather different story, however. Between 1755 and 1765 Greuze returns to three types of young women again and again: maidservants in varying states of decency and disarray, their dresses more or less disheveled, their breasts more or less exposed [FIGURE 22]; young mothers and nursemaids (and their charges) in rustic interiors [FIGURE 23]; and innocent adolescents, about to awaken to the first stirrings of love [FIGURES 3, 27]. Greuze situates these genre scenes in more or less the same setting; costumes are interchangeable; accessories migrate from one canvas to another (one is put in mind of Watteau's box of theatrical props). Thus, from *The Broken Eggs* [FIGURE 2], painted in 1757, reappear the wicker basket with firewood in the background at left and the earthen bowl atop the wooden tub in the foreground at right, now crammed together in *The Laundress*. The red mule, or backless shoe, worn by the heroine of *The Neapolitan Gesture* [FIGURE 23] is identical to the one worn by Greuze's laundress. Linen, laundered or not, is ubiquitous: it appears in

Figure 22
Jean-Baptiste Greuze, *Indolence*, 1756–57. Oil on canvas, 64.8 × 49.9 cm (25½ × 19¹¹⁄₁₆ in.). Hartford, Connecticut, Wadsworth Atheneum (1934.11), The Ella Gallup Sumner and Mary Catlin Sumner Collection Fund.

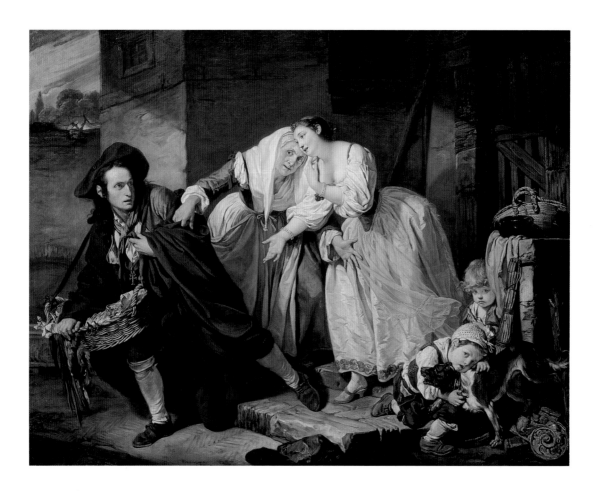

Figure 23
Jean-Baptiste Greuze,
The Neapolitan Gesture,
1757. Oil on canvas,
73 × 94.3 cm (28¾ ×
37⅛ in.). Massachu-
setts, Worcester Art
Museum, Museum
Purchase, Charlotte E.
W. Buffington Fund.

Figure 24
Jean-Baptiste Greuze,
Silence!, 1759.
Oil on canvas, 62.2 ×
50.5 cm (24½ ×
19⅞ in.). London, the
Royal Collection
(Photo © Her Majesty
Queen Elizabeth II).

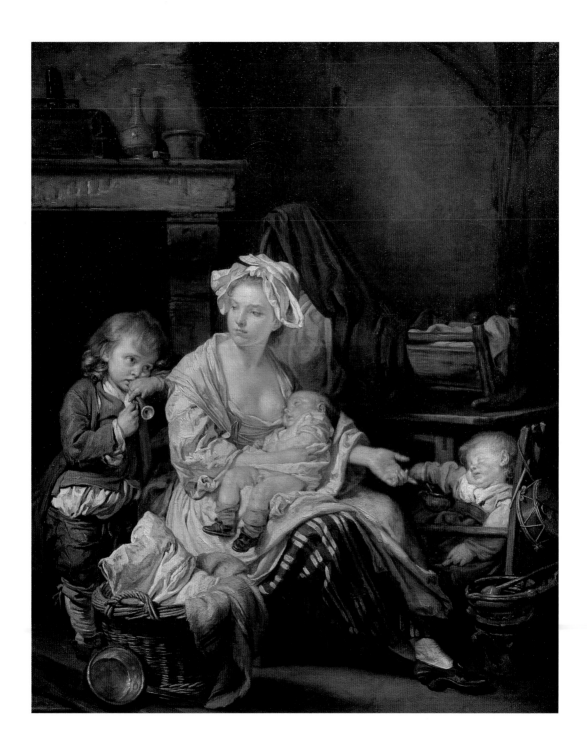

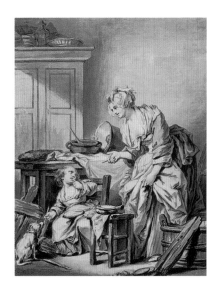

the foreground of *Silence!* [FIGURE 24], in drawings such as *The Motherly Reprimand* [FIGURE 25], and is everywhere, hanging from a clothesline, draped over furniture, in *The Wet Nurses* [FIGURE 26].

Such recycling of motifs and accessories notwithstanding, Greuze prepared each of his genre paintings with the deliberation of a seasoned academician. "Make studies before you start painting, above all drawings," he advised one of his pupils, and Greuze's conscientiousness in this regard was widely remarked upon.[67] If we consider *The First Lessons in Love* [FIGURE 27], a painting of similar date and dimensions to *The Laundress* (although more summary in execution), we gain some insight into his meticulous working method. For this single-figure composition, Greuze drew the model both nude and clothed, as well as studying her head in a lively drawing in red chalk [FIGURE 28]. He might also have made separate studies of her hands and arms.[68] No preparatory drawings have survived for *The Laundress,* although a red chalk *tête d'expression* [FIGURE 29] can be related to the laundress's face.[69] The drawing is very close indeed— the turn of the head, the hair peeking though the cap, the folds of the kerchief around the neck are exactly as they appear in the painting—but Greuze's model here is less pretty, with fuller cheeks and a surly expression.

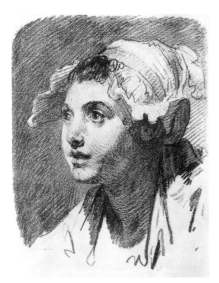

If Greuze modified and sweetened the model's appearance in the finished work, he did not idealize her excessively, much as he may have been tempted to do so. The X-radiograph of *The Laundress* [FIGURE 30] shows that Greuze initially painted her face as a more regular oval, with a perfect chin, but that, in the end, he remained faithful to the more fleshy physiognomy of his model: her broad cheek makes its way into the painting after all.[70]

Closer inspection of Greuze's daydreaming servants, beleaguered young mothers, and wide-eyed virgins helps situate *The Laundress* in a moral universe somewhat apart from the domestic realm that Greuze normally chose for his single-figure genre paintings. The laundress engages the viewer, certainly; but her look, while frank, is not openly lascivious, and the various layers of her costume for once succeed in keeping most of her body covered (not always the case with Greuze). The confinement of the space in which she works and the jumble of accessories are indeed suggestive of modest servant's quarters, but they do not evoke the disorder—both physical and moral—that is at the heart of such

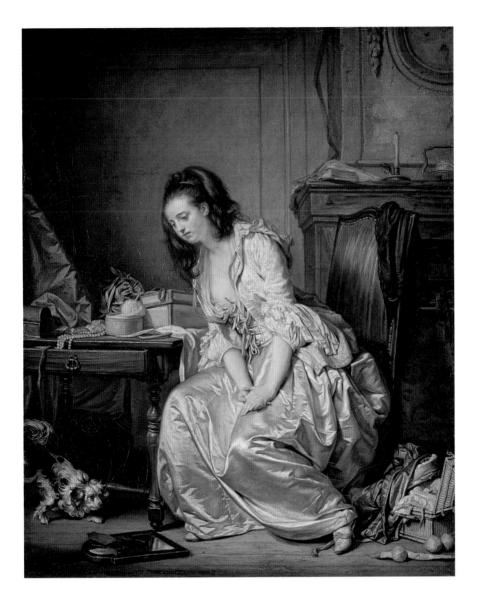

paintings as *Indolence* [FIGURE 22] or even *The Broken Mirror* [FIGURE 31] (one of Greuze's rare incursions into high life).[71] Greuze's laundress is unusually animated and self-possessed. She establishes the same relationship with the viewer as servants were beginning to establish with their masters; deference is gradually giving way to contract, the exchange of services for pay in a market economy.[72]

33

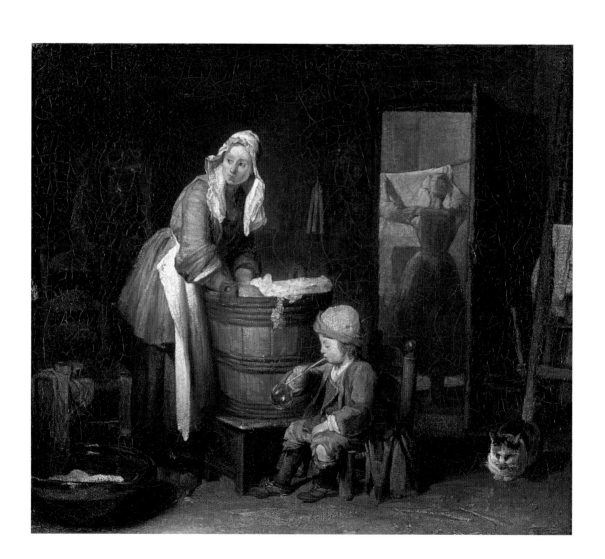

Chardin's Cabinet Paintings
and Other Influences on Greuze

What I like in a picture is a figure who speaks to the viewer
while remaining in character.[73]

—Diderot, *Salon of 1761*

In its lively but meticulous technique, as well as the vivacity of its characterization, Greuze's *Laundress* distinguished itself quite consciously from Chardin's depictions of domestic servants. Chardin's kitchenmaids and governesses are always detached from the viewer, seem unaware of the painter's scrutiny (and our own), and betray few signs of energy or intelligence, yet they are represented with a dignity and tenderness that were beyond Greuze's powers.[74] Compare, for example, Chardin's *Washerwoman* [FIGURE 32], painted in 1733, which Greuze may well have known through the version owned by the baron de Thiers, a notable collector of French and Dutch painting, or which he may have seen in Chardin's studio, since the artist kept a third version for himself.[75] Dressed in rough, heavy clothing, a white apron covering her blue woolen skirt, hair protected by a traditional cap (no lace or fancy ribbons here), and sleeves rolled up to her elbows (quite different from the fashionable ruffles of Greuze's laundress), Chardin's washerwoman engages in honest toil, her reddened, mutton-chop hand just visible through the suds and linen of her tub. The deliberate, granular laying on of earth colors helps create a mood that is absorbed and meditative. While the boy blowing bubbles is a stock *vanitas* image, and the cat, in other circumstances, might signal the erotic, these motifs shed their symbolism to return resolutely to the quotidian.[76] The rhythms of Chardin's cabinet painting are gentle, yet stately; its chiar-

Figure 32
Jean-Siméon Chardin (French, 1699–1779), *The Washerwoman*, 1737. Oil on canvas, 37 × 42.5 cm (14⅝ × 16¾ in.). Stockholm, Nationalmuseum (NM 780).

oscuro and subdued coloring reinforce the picture's hermeticism and sense of enclosure; only in the turn of the washerwoman's head—questioning, furtive even, but by no means ingratiating—does Chardin establish a connection with the world beyond the picture frame.

Each of these pictorial devices serves to underline the distance that separates Greuze's pert laundress—her linen impeccably starched, her hands soft and lily white—from Chardin's inscrutable downstairs maid. Yet we know that Greuze admired Chardin enormously. "They tell me," Diderot wrote in 1763, "that on his way to the Salon Greuze noticed Chardin's *Olive Jar*, looked at it, and walked by after letting out the deepest of sighs. Such praise is more concise, and more meaningful, than any that I can offer." [77] Greuze treated many of the same subjects as Chardin—not only laundresses, but scullery maids, maidservants, mothers, and children—and in the 1750s and 1760s both artists appealed to a similar clientele. [78] La Live de Jully, for example, owned four paintings by Chardin, two of which he lent to the Salon of 1757; [79] Jean-Antoine Levaillant de Guélis, chevalier de Damery (1723 - 1803), an avid collector of Greuze's drawings and the godfather of his daughter, lent a hunt still life by Chardin to the same Salon; [80] and, if Mariette is to be believed, Chardin's *Governess* [FIGURE 33], which was eventually acquired by Prince Joseph Wenzel of Liechtenstein for 1,800 livres, was initially destined for Jean de Jullienne, Watteau's great patron and the first owner of Greuze's *Silence!* [FIGURE 24]. [81]

As has already been mentioned, when Greuze returned from Rome to exhibit at the Salon of 1757, his genre scenes were deliberately placed on a line with Chardin's, "to facilitate the comparison." Greuze was able to stand his ground. "Both painters," it was noted, "lose and gain, each in their turn." [82] Cochin, who had no fondness for Greuze, noted how disastrous this sort of juxtaposition could be. "There were few paintings which could sustain themselves next to his (Chardin's), and it was said of him that he was a dangerous neighbor." [83] Yet both Greuze and Chardin seemed to welcome this rivalry, with the older artist ensuring that Greuze's work was well placed at the Salons for which he was responsible. [84] And if

Figure 33
Jean-Siméon Chardin
(French, 1699–1779),
The Governess, 1739.
Oil on canvas,
46.7 × 37.5 cm
(18⅜ × 16¾ in.).
Ottawa, National Gallery
of Canada.

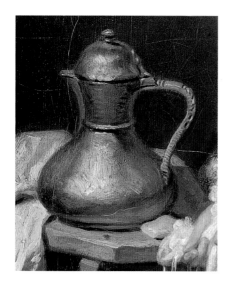

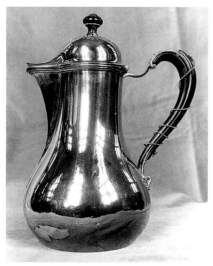

Greuze was far from considering himself Chardin's disciple (as the Goncourts later claimed), he found an elegant way to acknowledge his debts.

On a small wooden table at lower left in *The Laundress* Greuze has placed a pear-shaped pewter jug (or lidded kettle) that contemporaries would have recognized as a *marabout* [FIGURE 34]. Turkish in origin, the *marabout* was one of many receptacles in which water could be boiled in the hearth for cooking, but here it is the source of the hot water in which the laundress is rinsing her linen.[85] Its distinctive *bombé* design would be later used for fine silverware [FIGURE 35], but even in Greuze's *Laundress*, the *marabout* appears precious and slightly out of place among the more mundane earthen and copper pots. In Chardin's *Morning Toilet* [FIGURE 36] the *marabout* had assumed an even more curious function.[86] Here, the little pewter pot, isolated on the floor at bottom right, served as a *repoussoir*, while also mimicking the deportment of the figures by drawing attention to the slight angle at which the mother has to bend in order to adjust her daughter's coiffure. Greuze could not possibly have seen Chardin's *Morning Toilet*, which had been commissioned by the Swedish ambassador Carl Gustaf Tessin in 1740, exhibited at the Salon the following year, and shipped off to Stockholm quickly thereafter.[87] But he would have been familiar with the composition through Lebas's engraving, first published in December 1741 and advertised in the Parisian press on numerous occasions thereafter, most recently in November 1760.[88] The migration of the *marabout* from Chardin's *Morning Toilet* to Greuze's *Laundress* may be purely fortuitous, but with an artist as economical as Greuze, each detail signifies: thus does a pewter pot assume the poignancy of an homage.

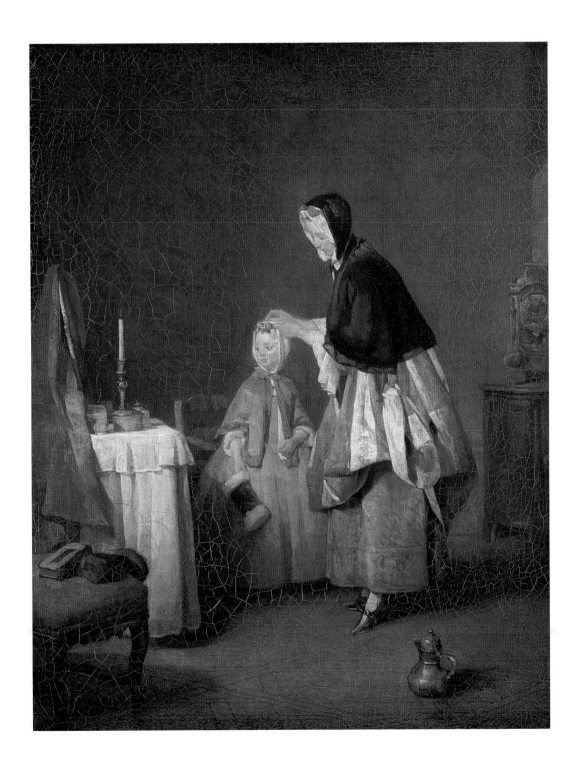

However, it was not Chardin, but David Teniers the Younger (1610–1690) [FIGURE 37] whom critics routinely cited as the model for Greuze's genre painting (just as they had evoked his name when Chardin first exhibited in the 1730s).[89] The *Correspondance Littéraire* characterized Greuze's submission to his first Salon as "pictures in the Flemish taste" (*dans le goût flamand*); his paintings were praised for their "naivety," "expressiveness," and "truthfulness"—terms consistently applied to the Dutch seventeenth-century masters.[90] In his enthusiasm for *The Marriage Contract*, Diderot embarked upon an extended comparison between Greuze and Teniers: "Teniers paints everyday life with more truthfulness, perhaps . . . but Greuze's world is more attractive, and is painted with greater elegance and gracefulness."[91] If, in Diderot's opinion, Teniers was a superior colorist to Greuze, this was honor by association; did not Diderot claim elsewhere that he would give ten Watteaus for one painting by Teniers?[92]

Among eighteenth-century theorists and writers on the arts, Teniers was the most popular seventeenth-century Northern artist, cited more frequently than either Rubens or Rembrandt. His paintings were also more accessible than theirs, since his work was reproduced in greater quantity than any of his contemporaries.[93] In advertising his stock in the *Mercure de France* in November 1760, the engraver Jean-Philippe Lebas listed prints after no fewer than sixty-nine compositions by Teniers, by far

Figure 38
Jean-Baptiste Greuze,
Boy with Lesson Book,
1757. Oil on canvas,
62.5 × 49 cm
(24⅝ × 19¼ in.).
Edinburgh, National
Gallery of Scotland
(NG 436).

the largest edition devoted to a single artist.[94] And in his early years as a collector, La Live de Jully had owned no fewer than six paintings by Teniers, including one that showed "a woman drawing water from a well."[95]

 In genre paintings such as *The Laundress*, Greuze was consciously responding to the growing fascination for seventeenth-century Dutch and Flemish cabinet pictures. Anita Brookner was the first to point out that the despondent girl in Greuze's *Broken Eggs* was based on Van Mieris's *Slattern*, a composition with which Greuze was familiar through Moitte's engraving.[96] Some of Greuze's early paintings of children—*The Sleeping Boy* (1755; Montpellier, Musée Fabre) owned by La Live de Jully, or the *Boy with Lesson Book* (1757) [FIGURE 38], painted for the chevalier de Damery—are distinctly Rembrandtesque in palette and handling, and

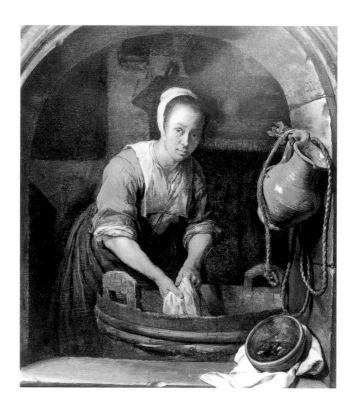

Greuze's debt to Rembrandt is apparent in any number of pen-and-ink drawings from this period. By the middle of the century, it was commonplace for collectors to pair their seventeenth-century cabinet pictures with works by promising contemporaries working in a compatible style.[97] La Live de Jully, who eventually divested himself of four of his Teniers, noted that, at the start of his activities as a collector, he had "continued to acquire works of the Flemish school, while assembling my cabinet of French painting."[98] And in the collection of the comte de Vence, a fellow Honorary Member of the Academy, Greuze's *Portrait of Joseph* (1755; Paris, Musée du Louvre) had been hung next to one of the proprietor's many portraits by Rembrandt, without "finding itself at all out of place."[99]

 After Rembrandt himself, it was to Rembrandt's pupils and contemporaries that Greuze was most indebted. In the case of *The Laundress*, the painting shares affinities with Gabriel Metsu's tiny panel of the same

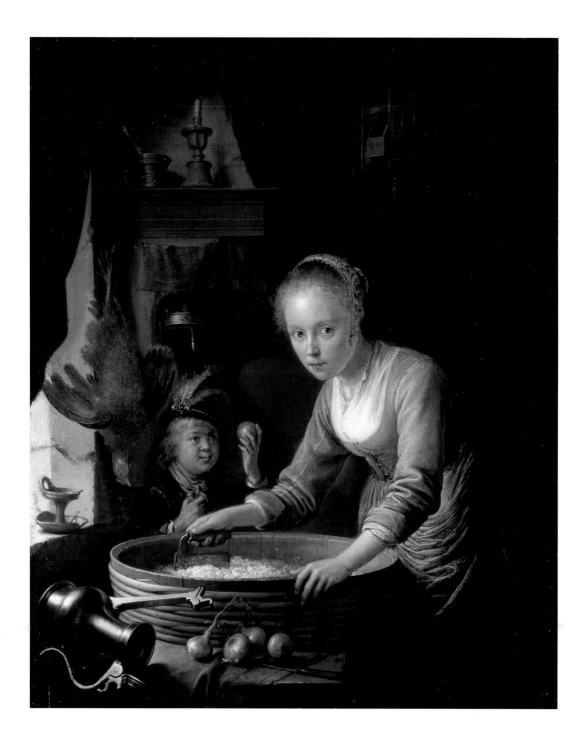

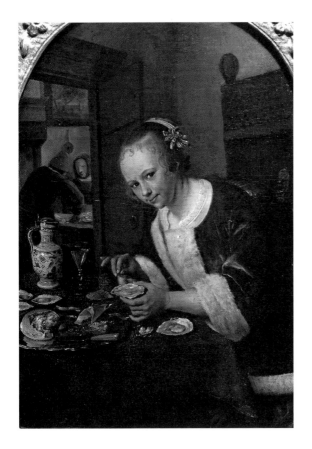

title, in which a rather timid maidservant washes linen in a wooden basin [FIGURE 39].[100] Greuze's protagonist is every bit as worldly as the pert figure in Gerard Dou's *Girl Chopping Onions* [FIGURE 40], an image, overtly amorous in its symbolism, that was available to an eighteenth-century audience through Surugue's engraving.[101] In typology and mood, however, Greuze is perhaps closest to Jan Steen, whose wanton *Girl Offering Oysters* [FIGURE 41] makes explicit the license and sensuality that are but alluded to in *The Laundress*.[102]

And what of Teniers himself? As Dezallier d'Argenville had noted, Teniers's "principal talent" had been in "landscapes enlivened by small figures," a manner of proceeding that had little in common with that of Greuze.[103] Beyond the most general shared interest in rustic types, the relationship between the two artists would be hard to explain on visual grounds alone. Similarly generic was the characterization of Greuze, by connoisseurs such as Gougenot and Mariette, as a "painter of *bambochades*" (the reference here is to the lowlife genre [*bambocciata*] invented by Pieter van Laer and his followers in Rome around the middle of the seventeenth century).[104]

Since French art theory did not as yet recognize the painting of everyday life as a distinct category within the hierarchy of the genres, either Teniers's authority or that of the Bambocciantì were invoked to valorize, and give pedigree to, Greuze's enterprise. In the Academy's classification, history painting, driven by "invention," was distinguished from the subordinate genres—portraiture, landscape, animals, fruits, and flowers (no mention of rustic subjects here)—each considered to be concerned

primarily with "imitation."[105] Genre painting, as we think of it today, simply did not exist as an independent aesthetic category for most of the eighteenth century. When Diderot ruminated on "genre," he understood the term in its most limited sense, as still life.[106] In his definition of "genre" for the *Encyclopédie*, Watelet maintained the classic distinction between the intellectual nature of history painting ("invention") and the mimetic function of the lesser genres ("imitation"): only in his reworking of this entry, twenty years later, would he allow that "actions and scenes of everyday life" constituted a legitimate field of artistic endeavor.[107]

Despite the enormous critical and commercial success of Greuze's genre paintings, the artist would always feel the stigma of working on the margins of the academic hierarchy. Hence his regrettable decision in August 1769 to seek full membership in the Academy as a history painter with *Septimus Severus Reproaching Caracalla* [FIGURE 6]. That Louis Lagrenée, an artist with some twenty years of service in the Academy's system, took it upon himself to point out the deficiencies in Greuze's draftmanship, could only have compounded Greuze's humiliation before the assembled company.[108] Two of Lagrenée's insipid Roman genre scenes [FIGURE 42] were hanging next to *The Laundress* in La Live de Jully's "Salon sur le Jardin": there, at least, artistic precedence was not in question.[109]

The Brutal Business
of Laundering Linen

Beware of linen! It's the motto of every Parisian
He fears the beetle
and the brush of the laundresses.[110]

—Louis-Sébastien Mercier,
Tableaux de Paris, 1782–83

Leaving to one side Greuze's debts to Chardin and the seventeenth-century Northern *petits maîtres*, it was the vigorous naturalism of his Salon submissions that so impressed critics in the 1760s.[111] *The Laundress* was "precious for its truth";[112] Diderot found "a great truthfulness" in the painting of the household utensils;[113] the head of the laundress was "flesh itself."[114] Above all, Greuze was praised for having ennobled *le genre rustique* while remaining true to his subject.[115] In *The Laundress*, it was argued, form and content were perfectly matched: "the delicacy and gracefulness of the girl's face are appropriate for one of her rank and profession."[116]

In front of such paintings, critics were quick to react to the slightest social nuance. A minor controversy arose over the exact status of the jealous sister in *The Marriage Contract* [FIGURE 19], the model for whom, in Diderot's opinion, had also served for *The Laundress*. Was she a servant or a sister? Diderot asked. A servant had no place leaning against the back of her master's chair; and a sister, happy or not, would surely have dressed more appropriately for the wedding ceremony. "I see how easy it is to make the mistake. Most of those who look at the picture take her for a servant, while the rest remain perplexed."[117] Grimm, on the other hand, had no difficulty in recognizing the figure as the elder sister. Her "ignoble expression" and shoddy apparel were the signs of her jealousy and resentment:

"she has not made herself pretty for her sister's engagement; for her, it's a day of mourning."[118]

By contrast, Greuze's single-figure genre paintings presented little such ambiguity, and *The Laundress* was admired for the transparency of its representation. Greuze's scrupulous, non-idealizing approach to his subject, and the care he lavished on accessories and costume, were welcomed as the powerful components of a new naturalism. Modernity was in the details. Greuze was at pains to suggest the modesty of the laundress's living quarters—the brick wall showing through the cracked plaster—while carefully describing the humble items that constituted her worldly goods: the rustic armoire, the earthen basins, the copper pots, the wicker basket. The laundress is seated on the wooden tub used for soaking her linen; sticks of firewood, for heating the water, are close at hand; washing hangs from a makeshift line attached to the wall and lies draped over the little wooden table at lower left. The girl is rinsing out a shirt, or a small sheet perhaps, and the linen hanging from the line confirms that she is a *blanchisseuse de gros linge*, or laundress of household linen (those who tackled more dainty items, such as undergarments, handkerchiefs, and stockings, were known as *blanchisseuses de linge fin*). Her costume is meticulously described: a white linen cap trimmed with a pink ribbon, its lappets pinned up to cover her hair; a blue-gray silk dress with ruffled sleeves (possibly a cast-off from her mistress, as was the custom in grander households); a red and yellow striped skirt of wool and linen, sturdy enough not to need the protection of the piece of grubby linen that she has pinned, in place of an apron, around her waist.[119]

However, three details in *The Laundress* help reorient us toward the fictive and suggest how mendacious is Greuze's naturalism, how little his representation conforms to the conditions of laundering (or servanthood) in Ancien Régime society. The *marabout* [FIGURE 34], despite its widespread usage in Parisian households, carries both a symbolic and an ornamental function in Greuze's painting, as has already been discussed. Equally unexpected is the dainty red Moroccan mule that reveals a finely stockinged ankle—neither of which might be said to have been the standard footwear of working laundresses. More elliptical still is a detail at the lower

47

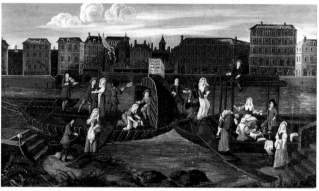

left-hand corner of the canvas: near the soapy water, cut off by the picture's edge, we catch sight of the laundress's most important tool—her beech beetle (or battledore), used for beating wet linen to remove the dirt.

As her lily-white hands and delicate features confirm, Greuze's little laundress occupies an ambiguous social realm—she is neither a working washerwoman, nor is she the ubiquitous female domestic, dressed in one of her mistress's "ill-fitting and faded hand-me-downs," who were to be found in most Parisian households.[120] That Greuze included the wooden paddle almost as an afterthought reinforces the distance between the sanitized (and radiant) hovel in which he has placed his model and the rough-and-tumble world of the laundress in eighteenth-century Paris, a world whose rituals and customs inspired a surprisingly rich vein of visual and literary imagery. It is within these contexts that *The Laundress* now needs to be assessed.[121]

Although they were never part of a guild or corporation, laundresses had been recognized as a profession since the fifteenth century, and the nature of their work remained more or less unchanged throughout the seventeenth and early eighteenth centuries. "We are off to beat our washing on the riverbank / To spend the full day / Cleaning the household linen and the daintier items": thus ran a refrain from the *Ballet des rues de Paris*, danced at Versailles, before Louis XIII, in 1647.[122] These verses draw attention, firstly, to the fact that the washing of clothes in Ancien Régime

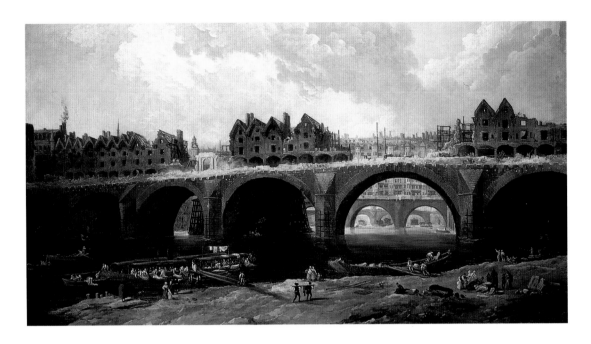

Paris was site-specific: laundering was done on the banks of the Seine [FIGURE 43], with the Quai de La Grenouillère, between the Pont Royal and the Invalides (today's Quai d'Orsay and Quai Anatole France), as the preferred location. As many as five hundred *blanchisseuse de gros linge* congregated on the banks of the Gros Caillou, while up river, in the heart of the city, those who washed the smaller items (*blanchisseuses de fin*) tended to work between the Pont Neuf and the Petit Pont [FIGURE 44].[123] So filthy was this section of the Seine that, in the summer months at least, laundresses were prohibited from using the river, "because of the infection and impurities of the stagnant water, which can cause dreadful illnesses" (swimming and bathing were also proscribed).[124]

Because of their number—and because of the demand for clean linen (a point to which we shall return)—laundresses frequently worked in boats moored along the banks of the Seine in the heart of the city [FIGURE 45]. Lacaille counted eighty "little boats for the use of laundresses"

MEMOIRE

P O U R les Blanchiffeufes de gros Linge à la
Grenoüillere , Demandereffes.

C O N T R E *Monfieur le Procureur General,*
Deffendeur.

D E U X Particuliers ont furpris au Bureau de
l'Hôtel-de- Ville une Sentence, à la faveur de
laquelle ils fe propofent de lever une Taxe jour-
naliere de 4.f. par Tête fur quatre ou cinq cent
Perfonnes : une nouveauté fi onereufe merite
une ferieufe difcuffion , & il ne feroit pas jufte
que la Sentence, dont il s'agit, fût executée par provifion. Voici
le Fait dont il eft queftion.
 Les nommez Couk & Villiot ne fçachant que faire des débris
d'un grand nombre de vieux Bateaux, ont imaginé d'en conf-
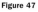
A

Figure 47

Mémoire pour les
Blanchisseuses de gros
Linge à la Grenouillère,
Demanderesses, 1739–
40. Paris, Bibliothèque
Mazarine. (Photo:
National Gallery of
Canada.)

[FIGURE 46] in his *Description de la ville et des faubourgs de Paris*, published in 1714,[125] and modern historians have estimated the number of boats as anywhere between seventy-seven and ninety-four, accommodating as many as two thousand workers.[126] This was the spectacle that greeted the Reverend William Cole, returning to Paris in 1765 after an absence of some twenty years:

> Notwithstanding the Beastliness & Filth of the River Water, both Sides of the Seine in the City of Paris are covered with large covered Boats, or rather Water-Houses, in which live all the Washer-Women of Paris; who hang continually over the Sides of the Boat & so beat the Linen with flat Pieces of Wood to get them clean.[127]

Earlier in the century, the city of Paris had attempted to coerce the *blanchisseuses de gros*, who worked down river at La Grenouillère, into using these laundry boats, charging them a daily rate of four sous, with an additional rental fee for the indispensable tub (*baquet*).[128] After a year of litigation, on August 31, 1740 the laundresses succeeded in reversing the city's ordinance. Appealing to their right, "from time immemorial," of being allowed to wash clothes on the banks of the river, they argued that the laundry boats were too small to accommodate the quantity of linen that they laundered—which included some of the dirtiest, used by butchers and "autres Gens de Métier." No matter how many pieces of *linge fin* were washed in the laundry boats, such linen was never "considerable in volume"; whereas the comparable amount of *gros linge* created "moun-

Figure 48
François Chauveau
(French, 1613–1676),
Frontispiece for
*Ordonnances de Louis
XIV*, 1676. Engraving,
7.5 × 17 cm
(3 × 6⅝ in.). Paris,
Bibliothèque Nationale.

tains of washing that would take up the entire boat, leaving no room for the laundresses themselves." This spirited defense [FIGURE 47] won them the case, which they celebrated by paying for a Te Deum at Saint-Sulpice and setting off fireworks from one of the egregious laundryboats.[129]

Maître Georgeon, who had been retained to plead the laundresses' case, noted that "river folk are not easily open to persuasion,"[130] and, even though they were not attached to one of Paris's 127 trade guilds, these rough working women were bound by a strong sense of community. Access to the riverbank was crucial to their livelihood, and, as we have seen, they fought to protect it. When, on August 8, 1721, at seven in the morning, rubbish from the outskirts of Paris (to be used for compost) was transported to La Grenouillère, from whence it was to be taken by boat to the duc de Noailles's château at Saint-Germain-en-Laye, some three hundred laundresses converged on the unsuspecting carters, unharnessed their horses, and prevented them from unloading the refuse. The rebellious washerwomen had to be dispersed by bayonets; their ringleader, La Brandenbourg, was imprisoned for three weeks. Yet the reason for their civil disobedience was quite simple. As the transcript noted, despite assurances that the transfer of refuse "would cause no inconvenience," the laundresses "did not want the unloading to take place at this site."[131]

As both these incidents suggest—and as is confirmed by any number of views of Paris [FIGURE 48]—professional laundresses operated outside the home, on the banks of the river. They worked, more often than

not, on their knees [FIGURE 49] and relied upon trusted utensils such as their bat, washboard, and tub. Laundering was a lengthy process, as well as being labor intensive. First, the washing was soaked (*essanger le linge*) before being placed flat, layer upon layer, in the tub. Water, to which cinders and soda had been added as a detergent, was heated in a large copper pot; once boiling, it was poured over the washing and allowed to drain from the tub. This procedure was repeated continuously over a period of eight hours, before the laundry was given a final soaking in hot water, kept at below boiling, for nine hours. The washing was then removed from the tub and transferred to the river—either to a laundry boat or the bank itself—where it would be washed again and beaten to remove the dirt. The clean laundry would be laid out to dry on the river bank or brought back to hang from the laundress's window—the *Encyclopédie* recommended drying in the fields for three consecutive days!—after which it would be folded before being ironed.[132]

As has been noted, the washing of clothes was not a major concern of the overburdened maidservant. Parisians from a fairly wide eco-

nomic and social range regularly sent their laundry out,[133] and, as a result, social historians have noted the scarcity of receptacles for washing clothes and linen in eighteenth-century domestic inventories.[134] The elaborate protocol for the washing of linen, as well as the widespread demand for the laundresses' services, had developed, in part, because the cleanliness of body linen (and of clothing in general) came to be considered as the primary index of personal hygiene. During the sixteenth and seventeenth centuries, fear of plague had effectively put an end to private and public bathing, and only in the 1730s and 1740s would full immersion in water—bathing—become fashionable among the elites.[135] By mid-century, the custom was gaining more general acceptance: Philip Thicknesse, writing in September 1766, commented that,

> The various kinds of washing chairs, *biddets*, etc. that are exposed to sale at almost every shop in Paris, plainly shew, that partial bathing is as much in practice in modern France as general bathing was in old Rome.[136]

In place of bathing—partial or general—it had been sufficient to wipe one's face and hands each morning and desirable to change linen as frequently as possible [FIGURE 50]. Contact with water was not encouraged; in the words of one sixteenth-century authority, "to cure the goatlike stench of armpits, it is useful to press and rub the skin with a compound of roses."[137] Savot, in *L'Architecture Françoise* (1626) argued that bathing was unnecessary, "because of our use of linen, which today serves to keep the body clean more conve-

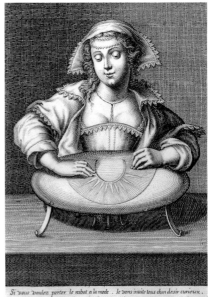

niently than could the steam baths and baths of the ancients."[138] These sentiments were echoed over sixty years later by Claude Perrault, architect of the Louvre, who justified the absence of bathrooms in modern buildings by reference to "the cleanliness of our linen and its abundance . . . worth more than all the baths in the world."[139]

Personal cleanliness thus came to be symbolized by clean linen: from this perspective, both the abundance of washing in Greuze's *Laundress* and the spotless apparel of the girl herself are suggestive of an admirably unsullied environment. Yet eighteenth-century commentators also felt compelled to point out the iniquities of the ways in which laundresses went about their work. The Reverend Cole was among the more outspoken:

> Their Ironing is full as bad as their Washing: so that it is no wonder that your Linen comes back torn to Pieces, dirtier than when it first went there, & just of the nasty dirty yellowish Colour of that beastly River. It is a pity they should have so much good Linen to spoil.[140]

His was not a lone voice. The *économiste* Goyon de La Plombanie, writing three years later, criticized the excessive handling to which laundry was subjected, arguing that it was more likely to be worn out than revived by the current methods of cleaning.[141] Laundresses' practices were notoriously rough. "There is no reason," noted the Supplement to the *Encyclopédie*, "for linen to be manhandled as it so often is. Either the laundress destroys it with her beating, or she reduces it to tatters by her brushing, an expedient to which she turns because of the inadequacies of her methods."[142] For Sébastien Mercier, such was the dismal state of laundering in Paris, it was remarkable that any washing survived at all:

> There is nowhere on earth, I repeat, nowhere, where washing is treated so badly. From a quarter of a mile you can hear the sound of the washerwoman's battledore; then she starts brushing with all her might, scraping the wash instead of soaping it. After your laundry has gone through this process half a dozen times, it's good for one thing only: bandages.[143]

In *The Laundress*, Greuze chooses to gloss over any such deficiencies: there is no washerwoman's brush in sight, the battledore is consigned to a corner off stage, and the only evidence of rough treatment is the piece of washing that lies, in knots, by the laundress's elegant slipper.

Clearly, by domesticating the activity of washing and gentrifying its principal practitioner, Greuze has journeyed far from the realities of eighteenth-century laundering. Yet in certain details he seems to engage with the contemporary debate on laundry reform. His laundress, play-acting though she might be, is shown to be sloppy with her washing—part of which has fallen to the floor—while the soapy water spills from the shallow basin. In her handling of the wash, she is also delinquent, since writers were quick to urge laundresses to let their linen soak in soapy water and to transfer it to the tub "without wringing it out, or expelling all the water." Greuze's laundress is to be commended, however, for not using the beetle (or battledore): the *Encyclopédie* would warn against "beating the linen too harshly; it is better to rub it gently between the hands."[145]

But it is in his celebration of the whiteness of her linen—the much desired *beau blanc* that was so difficult to obtain—that Greuze places himself firmly on the side of the enlightened consumer. Despite the disarray of her living quarters, the ubiquitous washing fairly shines, as does the round cap and kerchief of the laundress herself: note the two pieces hanging from the line (one of which is striped in blue), the sheet draped over the wooden table, and the bundle behind the laundress's right sleeve. In reality, Parisians had to make do with laundry that was always a little yellow. The very well-to-do might have their linen laundered in Holland[146]—and merchants in Bordeaux were known to send theirs to the slave colonies[147]—but critics were determined to find solutions nearer home. It was in order to achieve this *beau blanc* (or *blanc de neige*) that the *Encyclopédie* laid out such a taxing (and time-consuming) program of reform: it also urged laundresses to use indigo in the final rinse.[148] The visionary architect Jean-Jacques Lequeu (1757–1826)—whose illustrated *Sur le beau savonnage* added a surreal dimension to the

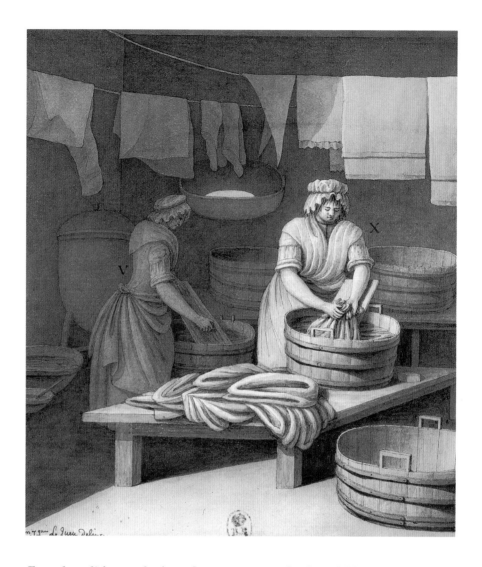

Encyclopedie's conclusions [FIGURES 51, 52]—based his treatise on the premise that laundering aim at "giving a fine whiteness to linen." [149] Soap, cut up with a knife, water mixed with bleach, indigo from Agra and soot from Rheims: these were among the various remedies proposed by the widow Alixotte, Lequeu's gentlewoman heroine, reduced to doing laundry and ironing to earn a living.[150] In contrast to all this, Greuze's laundress achieves the desired whiteness with the minimum of effort. Not, it should

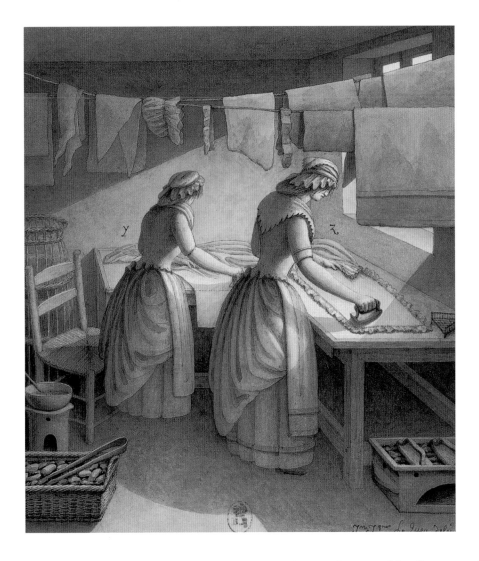

be added, that she has followed the pieties of the reformers. No, Greuze has played upon a potent domestic fantasy—washing that is "whiter than white"—thereby anticipating, by almost two hundred years, the techniques of modern-day advertising.

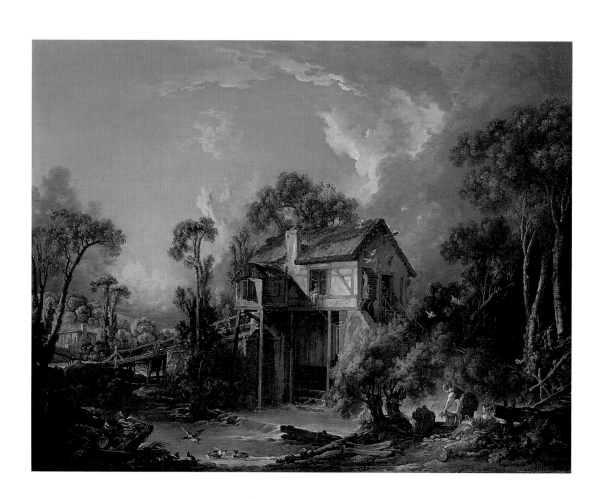

GREUZE'S NATURALISM
AND THE *GENRE POISSARD*

But ma, says I, he's a hard worker, I ain't no better then him,
and a laundress is no great lady;
oh, she says, there are laundresses and laundresses.
You're a laundress of fine linen,
and even if you only did the heavy stuff,
once you've got an education, my girl,
you'll realize that all that glitters is not gold.[151]

—JEAN-JOSEPH VADÉ,
Lettres de la Grenouillère

Unlikely image of a domestic though she is, Greuze's laundress also parts company with the standard portrayal of the subject in French art during the 1750s and 1760s. Laundresses and washerwomen abound as staffage figures in landscapes and genre paintings by Boucher [FIGURE 53], Fragonard, and Hubert Robert, where they occasionally occupy center stage as well [FIGURE 54].[152] The young women are invariably shown out of doors, in bucolic settings, attired in billowing skirts and low-cut bodices that evoke the pastoral [FIGURE 55]. Washing clothes may be far from their minds, as in the case of one of Fragonard's early masterpieces, *Blind-man's Buff* [FIGURE 56], where a voluptuous country lass flirts with a red-cheeked swain, her eyes peeking out from under her blindfold. The elements on the lower right-hand side of this composition—a large wash-board, copper basin, firewood, and dirty linen—all readily identify the heroine as a laundress and reaffirm the erotic associations of her profession.[153] Fragonard's beribboned laundress and Boucher's barefoot washerwomen are little more than shepherdesses in disguise, yet, paradoxically, in situat-

Figure 53
François Boucher
(French, 1703–1770),
The Mill at Charenton,
1758. Oil on canvas,
113 × 31.6 cm
(44½ × 12½ in.).
Toledo Museum of Art.

59

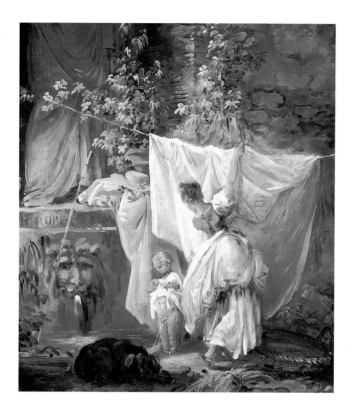

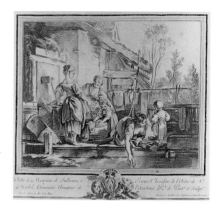

ing them at the water's edge—bending over their wash-
boards, bundles of linen on their head—there is greater
fidelity to the realities of washing linen than is to be
found in Greuze's *Laundress.*

In the late 1750s and early 1760s, Fragonard
and Robert would also populate their canvases and
drawings with Roman washerwomen who ply their trade
in dusky caves and caverns, congregate in grand pal-
aces and around public fountains [FIGURE 57], irrever-
ently hang their wash amid antique statues and monu-
ments, and can even be found working by the glorious
waterfalls at Tivoli [FIGURE 58] (laundresses will appear
in Robert's work until the Revolution).[154] Despite the
change of setting—and, in Fragonard's case, the trans-
formation of style—these laundresses are always acces-

sory figures, animating the landscape and providing picturesque effects, interchangeable with the amorous shepherdesses beloved by Boucher a generation earlier.

The primacy of this bucolic mode of representation may be suggested by one last example, almost exactly contemporary with Greuze's *Laundress.* Among the ninety plates that Gravelot designed for the *Almanach de la Loterie de l'École Militaire*—a suite of illustrations that charted the history of woman, "in keeping with the gallantry so natural to our Nation"—*La Blanchisseuse* (*The Laundress*) [FIGURE 59] showed two adolescent laundresses hard at work on the banks of the river, beating the linen and hanging it to dry.[155] Gravelot reflected on the disrepute into which the craft of laundering had long since fallen: did not Odysseus first encounter Princess Nausicaa, daughter of King Alcinous, while she was wash-

ing clothes with her maidens at the water's edge? Nowadays, he concluded, laundering was such a lowly occupation that "it cannot even inspire verses for a quatrain." [156]

However, it was popular literature—rather than poetry—and more specifically, the *genre poissard* (fish-market style), that enabled Greuze, in the early stages of his career, to craft a distinctive type of female domestic, be she laundress, maidservant, street peddler, or working mother.[157] The *genre poissard* took as it subject the fishwives and boatmen along the Seine [FIGURE 60] and the stallholders of Paris's markets at Les Halles, whose colorful, if occasionally foul-mouthed, language and amorous entanglements inspired a comic subgenre that would flourish during the 1740s and 1750s.[158] Leaving aside the Dutch seventeenth-century prototypes that have already been discussed, Greuze's "naturalism"—even more than Chardin's—was grounded in a sophisticated urban fascination

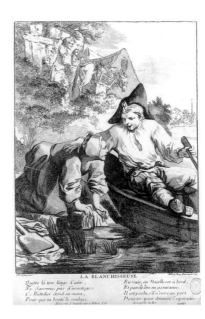

Figure 59
Hubert François Bourguignon Gravelot (French, 1699–1773), *The Laundress*, from *Almanach de la Loterie de l'Ecole royale militaire*, 1759. Engraving, 9.8 × 5.4 cm (3⅞ × 2⅛ in.). Paris, Musée Carnavalet. (Photo © Photothèque des Musées de la Ville de Paris. Cliché: Pierrain.)

Figure 60
Marguerite Thevenard (French, 1710–1770), after Charles-Nicolas Cochin (French, 1715–1790), *The Laundress*, 1737. Engraving, 26 × 20 cm (10¼ × 7⅞ in.). Paris, Musée Carnavalet. (Photo © Photothèque des Musées de la Ville de Paris. Cliché: Ladet.)

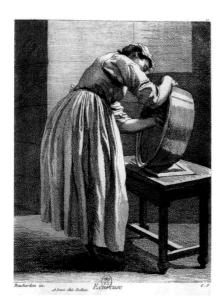

Figure 61
Anne-Claude-Philippe
de Tubières, comte de
Caylus (French,
1692–1765) after Edme
Bouchardon (French,
1698–1762), *Scullery
Maid (L'Ecureuse),*
1737. Engraving, 24 ×
18.5 cm (9½ × 7¼ in.).
Paris, Bibliothèque
Nationale, Cabinet des
Estampes (Oa. 132).

Figure 62
Anne-Claude-Philippe
de Tubières, comte de
Caylus (French,
1692–1762) after Edme
Bouchardon (French,
1698–1762), *Servant
Sweeping (La Bal-
ayeuse),* 1742. Engrav-
ing, 24 × 18.5 cm
(9½ × 7¼ in.). Paris,
Bibliothèque Nationale,
Cabinet des Estampes
(Oa. 132).

with such popular types: it is yet another example of the attraction for "lowlife" that inflects "high culture" in France again and again during the eighteenth and nineteenth centuries.[159]

A starting point for Greuze was Caylus and Bouchardon's immensely influential series of engravings, the *Cris de Paris* (*Cries of Paris*), published in five installments between 1737 and 1742. Depicting the lower classes (*le bas peuple*) in a variety of traditional occupations—street vendors, servants, provincial types—these single-figure compositions were often infused with a gentleness and dignity that had been conspicuously absent in earlier treatments of the theme.[160] Bouchardon's *Scullery Maid* [FIGURE 61] or *Servant Sweeping* [FIGURE 62] announce Chardin's lowly maidservants [FIGURE 63], whose unsentimental, plainspoken *gravitas* they share.[161] When Greuze approaches the same subject twenty years later, the results are a good deal more histrionic [FIGURE 64]. Gone is the quiet dedication to the household chores: the emphasis is on excess, clutter, and ripeness—and the servant's décolleté betrays the artist's unseemly prurience.

Among the sixty engravings produced by Bouchardon, *Les Ecosseuses de Pois* (*The Pea Shellers*) would also serve as the frontispiece

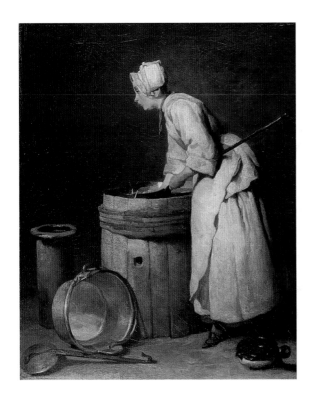

to Caylus's novel *Les Ecosseuses, ou les Oeufs de Pâques* (1745), in which six "good, stout gossips, seated in a butcher's shop" tell scurrilous tales about each other. This was one of the many short stories and improvised pantomimes (*parades*) that Caylus composed in the *genre poissard*, and like the commedia dell'arte for Watteau's generation, this genre initially received its most enthusiastic reception on the fringes of the official literary and theatrical worlds. *Poissard* characters and dialect appeared in the informal "parades" or pantomimes organized for private aristocratic entertainments; they infiltrated the repertory of the Parisian fairs; and they inspired vaudevilles and burlesques.[162]

Along with Caylus, gifted professional playwrights such as Panard, Lesage, and Favart began to write plays in the *genre poissard*. But the leading exponent of the genre, "le Téniers de la poésie,"[163] was Jean-Joseph Vadé (1719-1757), whose genius for re-creating the authentic jargon of fishwives and street vendors was marketed to brilliant effect by the

Figure 63
Jean-Siméon Chardin (French, 1699–1779), *The Scullery Maid*, 1738. Oil on canvas, 45.4 × 37.2 cm (17 7/8 × 14 5/8 in.). Glasgow, Hunterian Art Gallery, University of Glasgow, Scotland.

Figure 64
Jean-Baptiste Greuze, *The Scullery Maid*, 1757. Red, black, and white chalk, 52.1 × 35.9 cm (20 1/2 × 14 1/8 in.). Vienna, Graphische Sammlung Albertina (inv. 12766).

energetic theatrical impresario Jean Monnet. During the 1750s Monnet both refurbished the fair theaters at Saint-Laurent and Saint-Germain and revitalized the moribund Opéra-Comique: along with Favart's pastorals, he introduced Vadé's *poissard* characters to a wide and appreciative Parisian audience (more than twenty comic operas and parodies have survived, performed between 1752 and 1757).[164] Vadé's querulous flower sellers and fishmongers' wives were disdained by the more serious critics, but in the 1750s his plays were influential and a good deal more successful than would be Diderot's efforts in the *drame bourgeois*.[165]

An example of Vadé's prose works helps situate Greuze's *Laundress* within this more strictly contemporary aspect of popular culture. The *Lettres de la Grenouillère* is an epistolary novel written entirely in *poissard* dialect, whose heroine, Nanette Dubut—a laundress of fine linen (*blanchisseuse de linge fin*)—is enamored of Jérôme Dubois, a fisherman ("je suis fille d'honneur, il est honnête garçon"). Their romance is played out among the working communities at Gros-Caillou and La Grenouillère in the heart of Paris. Jérôme declares his love by offering Nanette a pair of eels and three pike; Nanette refuses them, but begins a correspondence with him, which is discovered by her mother, who is disdainful of a liaison with a mere fisherman ("Let her not play the great Lady," is Jérôme's response). The couple finally meet on a Sunday afternoon, but during a game of *Pied de Boeuf*, Jérôme suspects Nanette of favoring another and accuses her of treachery. In despair, she threatens to take holy orders as a *Soeur blanchisseuse* at the Hôtel-Dieu, much to her mother's consternation ("I'd rather you married than become a nun"); Jérôme, equally distraught, is on the point of signing up for the army. Nanette's final letter clears up any misunderstanding, and she urges Jérôme to marry her as quickly as possible: "Such pleasure will I take in being your servant and your wife."[166]

Although he is unlikely to have known Vadé personally—Greuze was living in Rome during the period of Vadé's greatest success at the Opéra-Comique—he may well have been familiar with the *Lettres de la Grenouillère*, published at least five times between 1755 and 1760.[167]

LA SERVANTE CONGEDIÉE.

Jour de Dieu depechons vite, que l'on détale *Vous alterés ma bourse et la foi conjugale*
Ne nous faisons point tirailler, *C'est trop prendre et trop travailler.*

A Paris chez Jeaurat, au bas de la rue des Fossés S.t Victor. A.P.D.R.

Vadé's plays had also influenced the genre-painter Etienne Jeaurat (1699–1789)—a contemporary of Chardin's and a friend of Greuze's—who exhibited *Les citrons de Javotte*, inspired by Vadé's poem of the same title, at the Salon of 1753.[168] In comparison with Greuze and Chardin, Jeaurat's depictions of servants and working girls are crude, and verge on the caricatural. Yet they are also an authentic visual response by a member of the Academy to a truly popular literary form.[169] Jeaurat's *Dismissed Servant* [FIGURE 65] also relates to *La Maltôte des cuisinières*, one of the tales included in the Bibliothèque bleue (cheaply produced editions primarily intended for the peasantry), in which an old kitchen maid passes on the tricks of her trade—how to cheat the mistress without being found out—to a young servant.[170] "Downstairs" folklore of this kind intrigued Greuze as well, and *La Maltote des cuisinières* inspired a black-and-white chalk drawing by him, of which he made a gift to his friend, the engraver Johann-Georg

Figure 65
Jean-Joseph Baléchou
(French, 1716–1764),
after Étienne Jeaurat
(French, 1699–1789),
*The Dismissed
Servant* (*La Servante
Congediée*), 1748.
Engraving, 37.2 × 26.5
cm (14⅝ × 10⅜ in.).
Paris, Bibliothèque
Nationale, Cabinet
des Estampes (DB. 27,
in fol.).

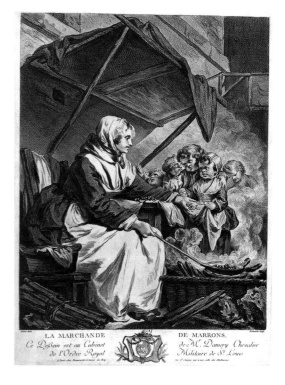

Wille, on November 27, 1759. In the absence of the drawing itself, Wille's appreciative journal entry must serve:

> M. Greuze, this serious, solid painter, has just made me a present of one of his excellent drawings, a sign of true friendship. The drawing represents a kitchen maid stand-ing next to a cupboard, reading or calculating in her ac-count book, after coming back from market, how she can best cheat her mistress. It is of great beauty, and boldly drawn[171]

Other drawings by Greuze from around 1760 also bear witness to his fascination with popular and *poissard* themes. From the *Cris de Paris* he appropriated street-vendor subjects such as *The Seller of Baked Apples* [FIGURE 66], *The Seller of Chestnuts* [FIGURE 67]—shown with *The Laundress* at the Salon of 1761—and *The Chimney Sweep*. In a more ambi-

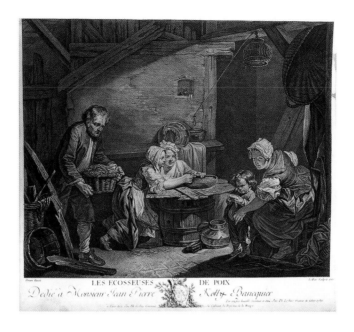

Figure 68

Jacques-Philippe Le Bas
(French, 1707–1783),
after Greuze, *The Pea
Shellers* (*L'Ecosseuses
de Pois*), 1760.
Engraving, 43 × 50.5
cm (16⅞ × 19⅞ in.).
Paris, Bibliothèque
Nationale, Cabinet des
Estampes.

tious composition, a painting based on the *Father Reading the Bible to His Family* in La Live de Jully's collection and known today through Lebas's engraving, Greuze treated *The Pea Shellers* [FIGURE 68]—the subject of Caylus's *poissard* tale. There is a strong family resemblance among the female figures in all these works—although, on closer inspection, those in the prints and drawings are coarser than Greuze's *Laundress*—and contemporaries would have had little difficulty in identifying them as *poissard* types. It was precisely this insight, made of *The Marriage Contract* "by a highly intelligent woman" (Mme d'Epinay, perhaps?), that so impressed Diderot.[172] Whereas, in her opinion, the male figures in this composition were recognizable countryfolk, the mother, fiancée, and other female characters all came from Les Halles. "The mother is a robust fruit seller or fishwife; the daughter, a pretty flower girl."[173] In the years following his return from Rome, Greuze sought inspiration less from the actual working women of Paris than from the most recent representations of them in popular culture.[174] In this regard, Diderot was more perceptive than he realized when he noted the affinity between Greuze's little laundress and the sulking sister in *The Marriage Contract*.

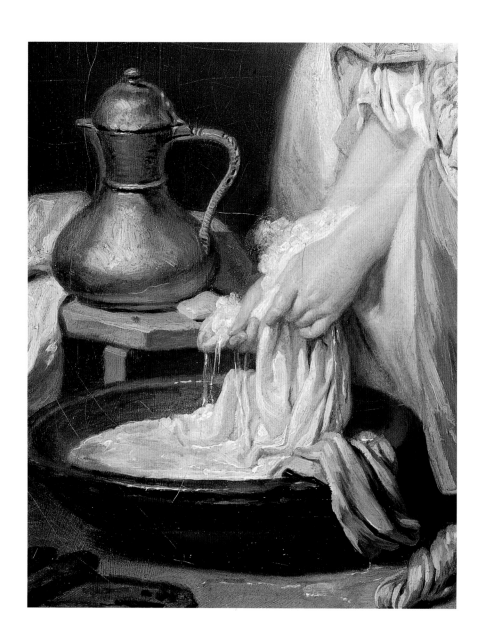

THE FEMALE DOMESTIC AS SEDUCTRESS

*It is as if the hand of a theatrical producer had had
a finger in all his compositions . . .
laundresses, in a picture by Greuze, do no laundering.*[175]

<div align="right">—EDMOND AND JULES DE GONCOURT</div>

Representation, in the *Laundress*, is informed (and, at times, mediated) by an amalgam of sources and influences—Chardin, Dutch cabinet painting, the *genre poissard*. Yet however telling the relationship between Greuze's genre painting and Parisian popular theater, his figures retain a sophistication and sensibility lacking in the fictional denizens of Les Halles and La Grenouillère. They are also unashamedly sensual. Decorous in her clothing she may be, but Greuze's laundress is far less so in her handling of the wash. Her strong fingers fairly caress the folds of wet linen [FIGURE 69]; soapy water, some of which has spilled onto the floor, oozes into the basin below.[176]

 Here Greuze was exploiting the fairly well established association of female domestics and easy virtue.[177] In the words of an early eighteenth-century verse, "Blanchisseuses et soubrettes / Du dimanche dans leurs habits / Avec les laquais leurs amis / (Car blanchisseuses sont coquettes)" (Laundresses and maidservants / In their Sunday bests / With their friends the footmen / [Because laundresses are coquettes]).[178] Maidservants, in literature at least, were often notoriously flirtatious. Jacob, the hero of Marivaux's *Le paysan parvenu*, whose morals are hardly exemplary, will not even consider marrying his mistress's maid, because, as he explains,

Figure 69
Jean-Baptiste Greuze,
The Laundress [detail].

> In our village, it was the custom to marry only maidens; if a girl had been a gentleman's chambermaid, she would have to make do with a lover. As for a husband, that was out of the question.[179]

The maidservant-as-seductress was a serviceable literary trope, yet such was the presumption of female depravity that an ordinance of 1730 made it a capital offense for a female domestic to engage in sexual relations with a minor living in the same household (the law was intended to protect sons under twenty-five years of age).[180]

In Ancien Régime society, laundresses were likely to be drawn from the lower reaches of the servant hierarchy, and it was commonplace for maidservants who had lost a position through pregnancy or petty theft to turn to washing clothes for a living. Actresses from the troupes that played in the fair theaters could earn extra money as dressmakers or laundresses (actors moonlighted as singing and dancing masters, or painters and carpenters).[181] Yet such was the modesty of the laundress's income—and the hard work involved in the job—that the young women might easily drift into prostitution and procuring. This, at least, is the conclusion to be drawn from the Paris police reports of the 1760s, in which impoverished laundresses are cited either as intermediaries in the clandestine network for kept women or as candidates for the positions themselves.[182] Cissie Fairchilds, who has studied patterns of domestic service in southwest France, noted that of 150 working prostitutes registered in the Bordeaux tax rolls for 1784, the majority listed their former occupation as laundress or seamstress.[183] Restif de La Bretonne (1734–1806) touched upon the marginality (and latent criminality) of laundresses in his vignette *Le secret des blanchisseuses*. The author is privy to a conversation between two unsuspecting laundresses who, on their way to the laundry boat, congratulate each other on how pretty they looked on their day off: "I wear white linen every Sunday, and it's always new." It soon emerges that they not only "borrow" their clients' clothing—"stockings, blouses, skirts, nothing belongs to me"—but that they carry on a thriving trade in renting it out.[184]

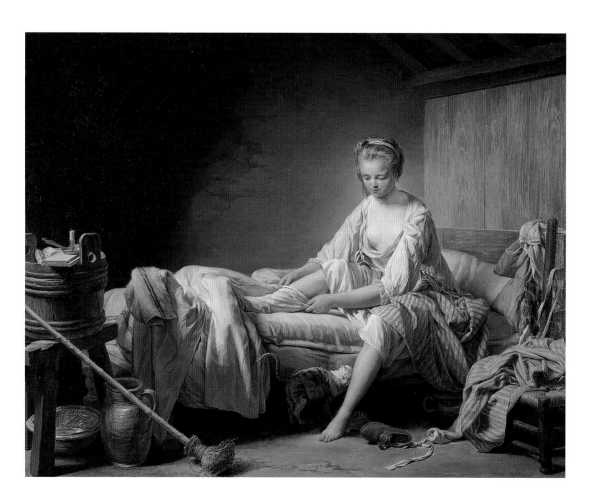

Figure 70
Nicolas-Bernard Lépicié
(French, 1735–1784),
Le Lever de Fanchon,
1773. Oil on canvas,
74 × 93 cm (29 ×
36½ in.). Saint-Omer,
Musée de l'Hôtel
Sandelin.

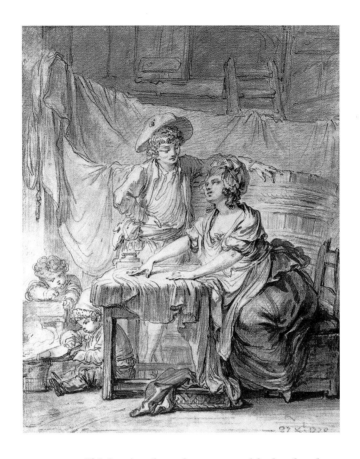

If laboring laundresses could also be dangerous laundresses, Greuze chose not to insist upon this identification. While the moral topography of his small paintings is often ambiguous in ways that Chardin's was not, in *The Laundress*, at least, Greuze maintains some distance from the license and depravity associated in the literary imagination with laundresses and domestics. In comparison with Lépicié's disheveled Fanchon [FIGURE 70] or Jean Touzé's brazen washerwoman [FIGURE 71], Greuze's laundress, while pert, seems determined to maintain her virtue intact.[185]

Yet there is evidence to suggest that a sexual reading of *The Laundress* would not have been out of place for the viewers at the Salon of 1761. In the first draft of his review for Grimm's newsletter, Diderot was

even more forthright on the attractions of Greuze's "little laundress." After the spirited description that makes its way into the final version— "The *Little Laundress*, who, seated on her tub, squeezes washing between her hands, is charming; but she's a rascal I wouldn't trust an inch"— Diderot added the brief sentence, "I'm too fond of my health" (*J'aime ma santé*).[186] Grimm excised this offending phrase from the text that circulated, but its implications are clear. The charms of the pretty girl are evident and within reach, but so are the risks: venery may lead to venereal infection. Just as British slang uses a term from laundering as a vulgar euphemism for a prostitute—"scrubber" entered the language in the 1960s—so in eighteenth-century French culture did the subject of laundresses (and female servants in general) invite the possibility of sexual impropriety, to be embraced or rejected as the artist saw fit. Greuze, almost invariably, does the former; Chardin, most resolutely, the latter.

It is a mark both of the subtlety and the refinement of *The Laundress* that its signals in this regard are mixed. "What visual and spiritual sensations are produced by this work, by the paintings of Greuze, by the prints engraved after his pictures?" asked the Goncourts.

> Is it the simple, healthful impression produced by a Chardin. Do we feel, confronted by these domestic scenes, the pervasive calm, the bourgeois serenity, the grave harmonies and instinctive decencies of *Le Bénédicité*, or *La Toilette du Matin*? Does he let us sense, like Chardin, the routine of the house, the felicities of mediocrity? [187]

In answering this question with a resounding negative, the Goncourts arrived at their fundamental insight into Greuze's art, one that still resonates for viewers of *The Laundress* today:

> The impression he gives is complex, disturbed, mixed. For his art suffers from something worse than a defect, it has a vice: it hides a kind of corruption, it is essentially sensual, sensual in its content and in its form, in its composition, its drawing, and its very brushstrokes.[188]

NOTES

1 Edgar Munhall, *Jean-Baptiste Greuze, 1725–1805*, exh. cat. (Hartford, Connecticut, Wadsworth Atheneum, and other institutions, 1976–77), p. 18.

2 Georges Wildenstein, "Quelques documents sur Greuze," *Gazette des Beaux-Arts* (October 1960), p. 231.

3 Munhall, *Greuze*, p. 18.

4 For Grimm's comment, see Diderot, *Salons*, "Salon de 1761," vol. 1, p. 146. Details on Greuze's early training at the Academy are to be found in Gougenot's unpublished "Album de voyage en Italie," quoted in Munhall, *Greuze*, pp. 18–19.

5 Idem, pp. 18, 32. Munhall cites an inscription on the *Seated Male Nude* (Paris, Bibliothèque Nationale), an early *académie* by Greuze, done at one of the sessions over which Natoire presided. After praising the drawing, Natoire pointed out certain faults of anatomy, to which Greuze replied, "Monsieur, you would be more than happy if you could produce anything as good as this." Natoire does not seem to have held Greuze's cheekiness against him.

6 A. de Montaiglon, *Procès-verbaux de l'Académie royale de Peinture et de Sculpture (1648–1793)*, 10 vols. (Paris, 1875–92), vol. 6, p. 418.

7 Munhall, *Greuze*, p. 18.

8 "I asked M. Greuze, the young painter of Bambochades . . . if he would care to accompany me, with my taking care of his expenses for the entire journey,"

see Gougenot's journal entry, cited in Munhall, *Greuze*, p. 52. Greuze's pupil and first biographer offered a slightly different account: "Greuze paid for the visit to Rome himself," Mme de Valori, "Notice sur Greuze et sur ses ouvrages," A. de Montaiglon, ed., *Revue universelle des arts*, 9 (July 1860), p. 250.

9 P.-J. Mariette, *Abécédario*, Ph. de Chennevières and A. de Montaiglon, eds., 6 vols. (Paris, 1851–60), vol. 2, p. 330.

10 Caylus's celebrated comment, from "La Vie d'Antoine Watteau, Peintre de figure et de paysages," a lecture given at the Academy on February 3, 1748, see Pierre Rosenberg, *Vies anciennes de Watteau* (Paris, 1984), p. 67.

11 On Greuze in Italy see Munhall, *Greuze*, pp. 19–20, 38–50, and, most recently, Heather Mcpherson, "Jean-Baptiste Greuze's Italian Sojourn," *Studies in Eighteenth-Century Culture*, 15 (1985), pp. 93–107; and Hélène Guicharnaud, "Un collectionneur Parisien, ami de Greuze et de Pigalle, L'abbé Louis Gougenot (1724–1767)," *Gazette des Beaux-Arts* 134 (July–August 1999), pp. 1–74.

12 "M. Greuze, undecided to the last, has finally made up his mind to remain in Rome a little longer" (M. Greuse, qui, indessi jusqu au moment du départ, c'et enfin déterminé à rester quelque tems à Rome), Natoire to Marigny, May 26, 1756, in A. de Montaiglon and J. Guiffrey, eds., *Correspondance des Directeurs de l'Académie de France à*

Rome avec les Surintendants des Bâtiments, 17 vols. (Paris, 1887–1908), vol. 11, p. 138 (Natoire's idiosyncratic spelling has been retained).

13 *Correspondance des Directeurs*, vol. 11, p. 136, in which Barthélemy's letter to Caylus of May 12, 1756 is reproduced.

14 Ibid., vol. 11, p. 138, "Il a beaucoup de méritte et peut porter for loin son genre."

15 "After being in Rome for several months, he will move to Venice for a further period of several months," Barthélemy to Caylus, May 12, 1756, *Correspondance des Directeurs*, vol. 11, p. 136.

16 Ibid., vol. 11, p. 165, Marigny to Natoire, November 28, 1756. Marigny instructed Natoire to assure Greuze "que je saisirai avec plaisir les occasions de son avancement lorsqu'elles se présenteront."

17 Ibid., vol. 11, p. 137.

18 On these works, see, most recently, Richard Rand, *Intimate Encounters: Love and Domesticity in Eighteenth-Century France*, exh. cat. (Hood Museum of Art, Dartmouth College, The Toledo Museum of Art, and the Museum of Fine Arts, Houston), 1997-98, pp. 150-154.

19 "It is decided that he will stay in Rome for the moment, the better to shine in Paris," Barthélemy to Caylus, May 12, 1756, cited in Munhall, *Greuze*, p. 20. Greuze left Rome for Paris on April 20, 1757; he exhibited eleven works at the Salon of 1757 and twenty at the Salon of 1759.

20 Diderot, *Correspondance*, G. Roth and J. Varloot, eds., 16 vols. (Paris, 1955-70), vol. 7, p. 104, Diderot to Falconet, August 15, 1767.

21 *Procès-verbaux*, vol. 6, p. 418; it is unlikely that Greuze ever followed this injunction.

22 See Edgar Munhall in Marie-Catherine Sahut and Nathalie Volle, eds., *Diderot et l'Art de Boucher à David*, exh. cat. (Paris, Hôtel de la Monnaie, 1984-85), pp. 222-227. Following Diderot, Munhall raises the intriguing possibility that Greuze himself may have decided that it was time to upgrade his membership so that he could be considered for the post of professor at the Academy that would be left vacant once Louis-Michel Van Loo took up the directorship of the École des Élèves Protégés.

23 Munhall in *Diderot et l'Art*, p. 257.

24 Quoted in Munhall, *Greuze*, p. 146.

25 *Diderot et l'Art*, p. 256, Diderot referring to this sketch, which has never been located, as "a tour de force."

26 *Procès-verbaux de l'Académie*, vol. 8, pp. 18-19. The minutes state that the designation of "peintre de genre" be repeated: "ce mot a été exigé par l'Académie."

27 For the overwhelmingly negative critical reaction to *Septimus Severus and Caracalla*, see Munhall in *Diderot de l'Art*, pp. 257-258. For the next decade and a half, Greuze would show his most recent work in his studio, timed to coincide with the second week of the Salon.

28 Denis Diderot, *Salons*, Jean Seznec and Jean Adhémar, eds., 4 vols. (Oxford, 1957-67), vol. 1, p. 134.

29 Ibid., vol. 1, pp. 98-99.

30 [Anonymous], "Les Tableaux de l'Académie de peinture, exposés dans le Sallon du Louvre, A Paris, 1761," *Journal Encylopédique*, 6 (September 1761), Coll. Deloynes, no. 1273.

31 [Anonymous], "Beaux-Arts," *Mercure de France*, October 1761, p. 160.

32 [Anonymous], *L'Avant Coureur*, September 1761, Coll. Deloynes, no. 1276.

33 Gunnar W. Lundberg, "Le graveur suédois Pierre-Gustave Floding à Paris et sa correspondance," *Archives de l'Art Français*, 17 (1931-32), p. 292, letter to Count Tessin, November 23, 1761.

34 Diderot *Salons*, vol. 1, p. 134.

35 [Anonymous], *Observations d'une société d'amateurs sur les tableaux exposés au Sallon cette Année 1761. Tirées de l'Observateur Littéraire de M. l'Abbé de La Porte* (Paris, 1761), p. 46. The abbé Bridard de La Garde, author of this pamphlet, was Mme de Pompadour's librarian, see Diderot, *Salons*, vol. 1, p. 76.

36 J. J. Guiffrey, *Notes et documents inédits sur les expositions du XVIIIe siècle* (Paris, 1873), p. 23, Cochin to Marigny, July 13, 1761. From 1737 the Salon always opened on August 25, the King's Saint's day (the Saint-Louis).

37 Casimir Stryienski, "Le Salon de 1761 d'après le catalogue illustré par Gabriel de Saint-Aubin (troisième et dernier article)," *Gazette des Beaux-Arts*, 30 (September 1903), p. 214; see also Émile Dacier, *Catalogues de ventes et livrets de Salons illustrés par Gabriel de Saint-Aubin*, 6 vols. (Paris, 1909-21), vol. 3, part 6, p. 64.

38 In his attack on the impoverishment of artistic training in France, and particularly the difficulties of studying from the live model ("we never see the nude anymore"), Diderot poured scorn on the current studio practice of employing soldiers and prostitutes as male and female models ("and such knowledge is not acquired by studying those prostitutes and guardsmen who are brought in four times a year"), Diderot, *Salons*, "Salon de 1761," vol. 1, p. 116.

39 Mme de Valori, "Notice sur Greuze et sur ses ouvrages," A. de Montaiglon, ed., *Revue universelle des arts*, 11 (July 1860), p. 253.

40 *Mercure de France*, October 1761, p. 160, "Un petit tableau représentant une jeune Blanchisseuse. Il appartient à M. *de la Live de Julli* [sic]."

41 Colin B. Bailey, ed., *Ange-Laurent de La Live de Jully: A Facsimile Reprint of the Catalogue Historique (1764) and the Catalogue raisonné des tableaux (1770)* (New York, 1988), p. viii. Although the present frame of *The Laundress* retains a cartouche with Greuze's name and was certainly fabricated in the eighteenth century, its ribbon-and-stave design may well be later than the more aggressive "goût grec" favored by La Live de Jully. It is quite possible that the Getty frame dates to the late 1770s, since it is known that the next owner of Greuze's *Laundress*, Count Gustaf Adolph Sparre, had new frames made for his pictures so that they would conform to the architecture of his Blue Drawing Room at Sahlgren, Göteborg; see Ingmar Hasselgren, *Konstsamlaren Gustaf Adolf Sparre* (Göteborg, 1974), pp. 205-206.

42 For the most recent study of this collector, and further bibliography, see Bailey, *La Live de Jully*, pp. vii-xliii. The three genre paintings by Greuze that were acquired by La Live de Jully in 1755 are *A Father Reading the Bible to His Family* (Paris, private collection), *The Blindman Deceived* (Moscow, Pushkin Museum), and *The Sleeping Schoolboy* (Montpellier, Musée Fabre).

43 Joseph Baillio, "Les portraits du dauphin et de la dauphine par Greuze," *Gazette des Beaux-Arts*, 122 (October 1993), pp. 135-148.

44 Lundberg, "Floding à Paris," p. 292. The connoisseur Pierre-Jean Mariette tells the story somewhat differently, with Greuze begging to be excused the commission, "'because,' he added, 'I do not know how to paint such heads,' by which he meant to criticize the disfiguring make-up on the Princess's cheeks," P.-J. Mariette, *Abécédario*, vol. II, p. 331. In order to complete this commission, Greuze was obliged to copy Jean-Martial Frédou's mediocre portrait of the dauphine (now in Rotterdam, Museum Boymans van Beuningen); see Baillio, "Les portraits du dauphin," pp. 146-147.

45 Pierrette Jean-Richard, *L'Oeuvre gravé de François Boucher dans la collection Edmond de Rothschild* (Paris, 1978), no. 1244.

46 In advanced circles, the enlightened art lover was encouraged to keep his participation in the "creative process" (to use an anachronistic term) to a minimum wherever possible, with Diderot an outspoken advocate for artists' rights: "In the end, one should never commission anything from an artist. If one wants a fine painting by him, all that needs to be done is to say 'Make me a painting and choose whatever subject you wish.' An even better and quicker way would be to buy one that is already painted," Diderot, *Salons*, "Salon de 1763," vol. I, pp. 229-230.

47 Burton Fredericksen, *Masterpieces of the J. Paul Getty Museum: Paintings* (Los Angeles, 1997), p. 81.

48 Pierre Remy, the dealer responsible for the auction of La Live de Jully's collection in May 1770, noted in his copy of the sale catalogue (now in the John G. Johnson collection, Philadelphia Museum of Art) that Greuze "had sold this painting for 600 livres" (Greuze l'a vendu 600 livres), see Bailey, *La Live de Jully*, p. xiv.

49 Remy noted that the purchaser was the dealer Jacques Langlier, "pour le cte. de Spa [sic]." The twenty-four-year-old Gustaf Adolph Sparre had recently arrived in Paris and would spend two years there before returning to Göteborg. Greuze's *Laundress* remained in Sparre's family until 1837, when it was acquired, along with rest of his collection, by another Swede, the Count de Geer, grandfather of Elizabeth Wachmeister (to whom the collection would be bequeathed in 1855). The painting descended in the Wachmeister family until its purchase by the Getty Museum in 1983; information from the curatorial file, Department of Paintings, J. Paul Getty Museum.

50 Bailey, *La Live de Jully*, pp. xxvii-xxviii.

51 Diderot, *Salons*, "Salon de 1761," vol. I, p. 140, "Récapitulation."

52 We know the placement thanks to the room-by-room guide to the collection (the *Catalogue historique*) that was published in 1764; see Bailey, *La Live de Jully*, pp. 100-102.

53 "Dined at M. de La Live's: saw his collection of French painting and sculpture. A few good, many indifferent: one room of fine Flemish," W.H. Lewis, ed., *The Yale Edition of Horace Walpole's Correspondence*, 34 vols. (London, 1937-71), vol. 7, p. 295 (journal entry for January 16, 1766).

54 *Mémories et journal de J.-G. Wille*, Georges Duplessis, ed., 2 vols. (Paris, 1857), vol. I, p. 200.

55 On Greuze and his engravers, see Fran-
çoise Arquié-Bruley, "Documents
notariés inédits sur Greuze," *Bulletin
de la Société de l'Histoire de l'Art
Français*, année 1981 (1983), pp. 125-
154.

56 Marcel Roux, *Bibliothèque Nationale,
Département des Estampes. Inventaire
du fonds français, Graveurs du XVIIIe
siècle*, 14 vols. (Paris, 1930-[1977]),
vol. 6, p. 10.

57 On the Fogg's replica, see the excel-
lent catalogue entry in Rand, *Intimate
Encounters*, pp. 157-158. Rand suggests
that this version could have been pro-
duced for a collector who had admired
the original at the Salon of 1761 (or,
indeed, in La Live de Jully's collection).

58 *Mercure de France*, December 1765,
p. 172, "la première porte cochère, à
gauche, en entrant par la rue des
Mathurins." Greuze's address at the rue
de Sorbonne is confirmed by the birth
certificate of his second daughter,
Anne-Geneviève, drawn up on April 16,
1762, see Henri Herluison, *Actes
d'État-Civil d'Artistes Français* (Paris,
1873), p. 166.

59 Diderot, *Salons*, vol. 1, p. 144.

60 *Mercure de France*, October 1761,
pp. 114-115.

61 For the most complete commentary
on the painting see Munhall in *Diderot
et l'Art*, pp. 222-227.

62 For a recent interpretation of the paint-
ing, which stresses its reformist,
physiocratic agenda, see Emma Barker,
"Painting and Reform in Eighteenth-
Century France: Greuze's *L'Accordée
de Village*," *The Oxford Art Journal*,
20 (1997), pp. 42-52.

63 We know this because Wille recorded
in his diary for July 17, 1761 that he had
just acquired one of Greuze's drawings
for the head of the father in *L'Accordée
de village*, "tableau qu'il fait actuelle-
ment," *Mémoires de J.-G. Wille*, vol. 1,
p. 173.

64 Diderot, *Salons*, "Salon de 1765,"
vol. II, p. 149.

65 Élie Fréron, in *L'Année Littéraire*, 6
(30 August 1761)—plagiarized by La
Garde in his *Observations d'une société
d'amateurs*—had noted that, taken
together, Greuze's paintings would
one day form "un Traité complet de
Morale domestique."

66 Diderot, *Salons*, "Salon de 1763," vol. 1,
p. 236.

67 "Faites des études avant que de peindre
en dessinant surtout," Greuze's advice
to the portraitist Joseph Ducreux, cited
in Munhall, *Greuze*, p. 66.

68 Edgar Munhall, "*The First Lessons
in Love* by Jean-Baptiste Greuze,"
The Currier Gallery of Art Bulletin
(1977), pp. 3-13.

69 The drawing is reproduced in F. Monod
and L. Hautecoeur, *Les Dessins
de Greuze conservés à l'Académie des
Beaux-Arts de Saint-Pétersbourg*
(Paris, 1922), no. 130, plate 53, and
catalogued in I. N. Novoselskaya,
*Jean-Baptiste Greuze: Drawings from
the Hermitage Collection*, exh. cat.
(Leningrad, The Hermitage, 1977),
p. 29.

70 The only other change of importance
revealed by the X-radiograph relates to
the left-hand side of the *marabout*
(pewter jug), which was initially cov-
ered by a fold of the washing; the
pentimento is visible to the naked eye.

71 On *Indolence* see Rand, *Intimate En-
counters*, pp. 147-149; on *The Broken
Mirror*, see John Ingamells, *The*

Wallace Collection Catalogue of Pictures, 3, French before 1815 (London, 1989), pp. 205-207.

72 This point is persuasively made by Cissie Fairchilds, *Domestic Enemies: Servants and Their Masters in Old Regime France* (Baltimore and London, 1984), pp. 15-20, 77-80.

73 Diderot, *Salons*, vol. 1, p. 135.

74 Philip Conisbee, *Chardin* (Oxford, 1985), especially pp. 106-132, chapter 5, "Little Pieces of Common Life."

75 For a discussion of the three autograph versions, see Pierre Rosenberg, *Chardin, 1699-1779*, exh. cat. (Paris, Grand Palais, and other institutions, 1979), pp. 197-200.

76 In the 1730s, Chardin had treated the theme of a young boy blowing bubbles as a more traditional vanitas (for example *Soap Bubbles*, versions in the National Gallery of Art, Washington, D.C.,and the Metropolitan Museum of Art, New York), see Rosenberg, *Chardin, 1699-1779*, pp. 204-210. In Boucher's genre paintings, most obviously *The Surprise*, circa 1725 (New Orleans Museum of Art), the cat is a thinly veiled symbol of feminine sexuality. For a fine discussion of the way seventeenth-century Dutch genre painting uses elements of reality to mediate Calvinist morality and dogma—a nuanced methodology that can be applied to the study of eighteenth-century genre painting in a Catholic culture—see Simon Schama, *The Embarrassment of Riches* (New York, 1987), pp. 475-480, "Housewives and Hussies: Homeliness and Worldliness" (especially pp. 412-418).

77 Diderot, *Salons*, "Salon de 1763," vol. 1, p. 223.

78 Conisbee, *Chardin*, pp. 27-28.

79 Chardin's *Kitchen Table*, 1755 (Boston, Museum of Fine Arts) and *Butler's Pantry Table* 1756 (Carcassonne, Musée des Beaux-Arts) were exhibited at the Salon of 1757 as "tirés du cabinet de l'École Françoise de M. de La Live de July [sic]," *Explication des Peintures, Sculptures, et Gravures de Messieurs de l'Académie Royale* (Paris, 1757), no. 33.

80 On Damery, who also owned genre paintings by Oudry and Jeaurat, see Munhall, *Greuze*, pp. 96-97; the *Still Life with Game, Gamebag, and Powder Horn* described in the Salon *livret* (no. 36) has yet to be identified.

81 "He thought he was painting it for M. de Jullienne . . . but it was actually acquired by a banker named Despuechs and was later purchased for 1,800 livres by M. le Prince de Liechtenstein during his ambassadorship to France," Mariette, *Abécédario*, vol. 1, p. 358. On the subsequent history of this painting, see Myron J. Laskin and Michael Pantazzi, *European and American Painting, Sculpture, and Decorative Arts: Catalogue of the National Gallery of Canada*, 2 vols. (Ottawa, 1987), vol. 1, pp. 74-79.

82 A. Renou, *Observations sur la physique et les arts* (Paris, 1757), p. 15.

83 Conisbee, *Chardin*, p. 115, quoting from Cochin's *Essai sur la vie de Chardin* [1780].

84 One example of Chardin's advocacy of Greuze, whose notoriously rancorous temperament soon began to disaffect his patrons, both public and private: At the Salon of 1765, Chardin hung Greuze's *Wet Nurses* [fig. 26] beneath Roslin's enormous *The Father Arriving at His Country Seat* (France, private

collection), a family portrait commissioned by duc Alexandre de La Rochefoucauld. Greuze had been a candidate for this prestigious commission and had submitted a preparatory design, but his erstwhile supporters, Watelet and Marigny, both promoted Roslin over him. For Diderot (and for others in the know), Chardin's juxtaposition was hardly innocent: "It is as if he had written underneath one of the paintings, 'A Model of Dissonance,' and under the other 'A Model of Harmony,'" Diderot, *Salons*, "Salon de 1765," vol. 2, pp. 160.

85 Annik Pardailhé-Galabrun, *The Birth of Intimacy*, translated by Jocelyn Phelps (Philadelphia, 1991), p. 135.

86 Rosenberg (*Chardin, 1699–1779*, pp. 274–276) was the first to identify the vessel on the floor in Chardin's composition as a *marabout*.

87 Pontus Grate, *French Paintings 2: Eighteenth Century* (Stockholm, 1994), pp. 91–93.

88 *Mercure de France*, November 1760, p. 172; "Le Négligé, ou la Toilette du matin," was offered for 1 livre, 10 sous.

89 In 1734, Chardin's submission to the annual one-day exhibition held at the Place Dauphine had included paintings "dans le goût de Teniers où l'on trouve une grande vérité," *Mercure de France*, June 1734, p. 1405.

90 Maurice Tourneux, ed., *Correspondance Littéraire, philosophique et critique, par Grimm, Diderot, Raynal, Meister etc*, 16 vols. (Paris, 1877–82), vol. 3, pp. 93–94 (September 1755).

91 Diderot, *Salons*, vol. 1, p. 143.

92 "Je donnerais dix Watteau pour un Téniers," Diderot, *Pensées detachées sur la peinture* (circa 1781), in *Oeuvres Esthétiques*, Paul Vernière, ed. (Paris, 1968), p. 749.

93 Oliver T. Banks, *Watteau and the North: Studies in the Dutch and Flemish Baroque Influence on French Rococo Painting* (New York, 1977), pp. 92–105.

94 *Mercure de France*, November 1760, pp. 175–177; for comparison, it should be noted that Lebas was offering reproductions of six compositions by Chardin, eight by Wouwermans, and twenty-one by Rubens.

95 Jean-Baptiste Descamps, *La Vie des Peintres Flamands, Allemands et Hollandois*, 4 vols. (Paris, 1753–64), vol. 2, p. 167.

96 Anita Brookner, *Greuze, The Rise and Fall of an Eighteenth-Century Phenomenon* (London, 1972), pp. 40–41.

97 On this wide, and fascinating subject—which remains underresearched—see Banks, *Watteau and the North*, and Hervé Oursel, *Au temps de Watteau, Fragonard, et Chardin: Les Pays-Bas et les peintres français au XVIIIe siècle*, exh. cat. (Lille, Musée des Beaux-Arts, 1985).

98 "Avertissement" to the *Catalogue historique* (1764), in Bailey, *La Live de Jully*, p. 109.

99 *Catalogue des tableaux de Monsieur le comte de Vence* (Paris, 1759), cited in Munhall, *Greuze*, p. 34. Greuze was not the only French artist so honored in this collection: the comte de Vence had also placed a pair of male academies by Jean-Baptiste Pierre (Hamburg, Kunsthalle) on either side of a painting by Rembrandt, next to which, it was claimed, "they hold up with regard to color, but they put the Flemish artist to shame by their correction and the elegance of their drawing," Descamps, *Vie des Peintres Flamands*, vol. 1, p. v (an example of cultural jingoism at its most sycophantic).

100 Metsu's *Maid Washing Clothes in a Wooden Basin* most recently appeared at Sotheby's, Old Master Paintings, New York, January 15, 1993, no. 113.

101 See Peter Sutton, *Masters of Seventeenth-Century Dutch Genre Painting*, exh. cat. (Philadelphia Museum of Art and other institutions, 1984), pp. 184-185. Greuze may also have been familiar with the painting itself, which was in the collection of the famous bibliophile Louis-Jean Gaignat (1697-1768).

102 H. Perry Chapman, *Jan Steen, Painter and Storyteller*, exh. cat. (Washington, D.C., National Gallery of Art, 1996), pp. 126-128.

103 Antoine-Joseph Dezallier d'Argenville, *Abrégé de la vie des plus fameux peintres et sculpteurs*, 4 vols. (Paris, 1762), vol. 3, p. 389.

104 Gougenot, recalling the trip to Italy in his unpublished "Album de voyage," referred to Greuze as "un jeune peintre de Bambochades," cited in Munhall, *Greuze*, p. 53; Mariette began his brief biography of Greuze with the statement "Il a choisi pour son genre celui des bambochades," *Abécédario*, vol. 2, pp. 329-330. The collector and theoretician Claude-Henri Watelet, whose portrait Greuze painted in 1765, defined the *bambochade* as "a genre that includes the representation of rustic nature, of Villagers' habitations, their customs, and their commonplace behavior," C.-H. Watelet and Pierre Lévesque, *Dictionnaire des arts de peinture, sculpture et gravure*, 5 vols. (Paris, 1792), vol. 1, p. 176. He might be describing any number of compositions by Greuze.

105 For an introduction to the Academy's hierarchy of the genres, see Nicolas Pevsner, *Academies of Art, Past and Present* (New York, 1973), pp. 60-80 passim; for its application in practice, Philip Conisbee, *Painting in Eighteenth-Century France* (Oxford, 1981), pp. 11-34. I have followed Watelet's definition of "Genre (*Peinture*)" in Diderot and d'Alembert, eds., *Encyclopédie, ou dictionnaire raisonné des sciences, des arts, et des métiers*, 17 vols. (Paris, 1751-65), vol. 7, pp. 597-599.

106 As is clear from his comments on Chardin at the Salon of 1765, which inspired the insight that "the category of painting we call genre is best suited to old men or to those born old; it requires only study and patience, no verve, little genius, scarcely any poetry, much technique and truth, and that's all," John Goodman, ed., *Diderot on Art* (New Haven and London, 1995), vol. 1, p. 60, *The Salon of 1765*. This is consistent with Diderot's shorthand for Roland de La Porte's Still Lifes at the same Salon, which he called "un Morceau de genre" and his distinction between history painting—which encourages morality and virtue—and genre painting, in which all "must be sacrificed to pictorial effect," with Van Huysum and Chardin cited as exemplars of this latter category, see Diderot, *Pensées Détachées*, in *Oeuvres Esthétiques*, p. 772.

107 Watelet and Levesque, *Dictionnaire des arts de peinture*, vol. 2, p. 412.

108 On this well-known episode, see Munhall's account in *Diderot et l'Art*, pp. 253-258.

109 Lagrenée's *Young Woman with a Pigeon* and *Young Woman Reading Music* recently reappeared at Christie's, Monaco, June 14, 1996, no. 38.

110 Louis-Sébastien Mercier, *Tableaux de Paris*, 8 vols. (Amsterdam, 1782-83),

vol. 5, p. 120 (chapter 397, "The Destruction of Linen").

111 "Where Truth is concerned, there is nothing lacking in the paintings of Monsieur Greuze: he is the painter of Nature, pure and simple," *L'Avant Coureur*, September 1761, Coll. Deloynes, no. 1276.

112 *Mercure de France*, October 1761, p. 160.

113 Diderot, *Salons*, vol. 1, p. 134.

114 *L'Avant Coureur*, September 1761, Coll. Deloynes, no. 1276.

115 "His brush ennobles the rustic, without diminishing its truthfulness," *Observations d'une société d'amateurs*, p. 46.

116 Ibid., p. 47.

117 Diderot, *Salons*, vol. 1, p. 144.

118 Ibid., p. 145.

119 For help with the terminology (and identification) of the laundress's costume, I am indebted to Dr. Aileen Ribeiro (written communication to the author, February 1998).

120 Sarah C. Maza, *Servants and Masters in Eighteenth-Century France* (Princeton, 1984), p. 25.

121 In what follows, I have relied extensively on Fairchilds, *Domestic Enemies*, Maza, *Servants and Masters*, and Daniel Roche, *La culture des apparences: Une histoire du vêtement (XVII–XVIII siècle)* (Paris, 1989).

122 "Nous allons battre à la rivière / Et passons la journée entière / A savonner gros et menu," Alfred Franklin, *La vie privée d'autrefois: arts et métiers, moeurs, usages des Parisiens du XIIe au XVIIIe siècle*, 27 vols. (Paris, 1887-1902), vol. 21, pp. 149-150.

123 Ibid., vol. 21, pp. 151-152. See also Alfred Franklin, *Dictionnaire historique des arts: métiers et professions exercés dans Paris depuis le treizième siècle* (Paris, 1906), p. 85.

124 Nicolas Delamare, *Traité de la Police*, 4 vols. (Paris, 1719-38), vol. 4, pp. 589-591.

125 Jean de La Caille, *Description de la ville et des fauxbourgs de Paris en vingt planches* (Paris, 1714), "Quartier Saint-André-des-Arts." See also, Alfred Franklin, *Les Anciens Plans de Paris: Notices historiques et topographiques* (Paris, 1880), p. 132.

126 Roche, *La culture des apparences*, p. 374.

127 Rev. William Cole, *A Journal of My Journey to Paris in the Year 1765*, F. G. Stokes, ed. (New York, 1931), p. 42.

128 Franklin, *La vie privée*, vol. 21, pp. 152-157.

129 [Me Georgeon], *Mémoire pour les Blanchisseuses de gros Linge à la Grenouillere, Demanderesses* (Paris, 1740), pp. 1-6. I have consulted the annotated copy in the Bibliothèque Mazarine, Paris (*A 11134*, 54e pièce).

130 Ibid., *Mémoire pour les Blanchisseuse*, p. 2.

131 Frantz Funck-Brentano, "Une révolte de blanchisseuses à La Grenouillère (1721)," *Revue Rétrospective*, 16 (January-July 1892), pp. 207-209.

132 Philippe Macquer, *Dictionnaire raisonné universel des arts et métiers*, 5 vols. (Paris, 1773), vol. 1, pp. 271-273. See also the article, "Blanchissage du Linge," in *Supplément à L'Encyclopédie*, 4 vols. (Amsterdam, 1776), vol. 1, pp. 906-908. The first edition of the *Encyclopédie* had not included an article on domestic laundry.

133 The young comte Mirabeau sent his linen to a laundress in Vincennes; his father paid the bills and his valet made the deliveries, see Legrain, "Souvenirs de Legrain, valet de chambre de Mirabeau," *Nouvelle Revue Rétrospective*, 2 (July–December 1901), pp. 365, 368. At the other end of the social spectrum, Mercier estimated that clerks and private tutors (*précepteurs*) could only afford to have their shirts cleaned once a fortnight, *Tableaux de Paris*, vol. 5, p. 117.

134 Pardailhé-Galabrun, *The Birth of Intimacy*, p. 135. Daniel Roche reached similar conclusions, "A Paris, on confie massivement son linge à blanchir à des ouvrières," Roche, *La culture des apparences*, p. 374.

135 Georges Vigarello, *Concepts of Cleanliness: Changing Attitudes in France Since the Middle Ages*, translated by Jean Birrell (New York, 1988), pp. 17–21, 94–103. Bathing would take even longer to find acceptance among the middle classes; the first public baths with hot water, Les Bains Poitevin, built on the Seine, were open to the public in 1761, at a cost of three livres a visit.

136 Philip Thicknesse, *Observations on the Customs and Manners of the French Nation* (Dublin, 1767), p. 94 (Letter 18).

137 Jérôme de Monteux, *Conservation de santé et Prolongation de la vie* (Paris, 1572), cited in Vigarello, *Concepts of Cleanliness*, p. 17.

138 Ibid., p. 60.

139 Ibid., p. 61.

140 Cole, *Journal*, p. 42.

141 Complaining of "the dreadful methods that are employed in the washing of linen," Goyon de La Plombanie concluded, "it is from laundering, and not from general usage, that linen is worn out so quickly," Goyon de La Plombanie, *L'Homme en société*, 2 vols. (Amsterdam, 1768), vol. 2, p. 47, cited in Roche, *La culture des apparences*, p. 376.

142 *Supplément à L'Encyclopédie*, vol. 1, p. 908.

143 Mercier, *Tableau de Paris*, vol. 5, p. 118.

144 *Supplément à L'Encyclopédie*, vol. 1, p. 907.

145 Ibid., vol. 1, p. 908.

146 "Certain rich individuals, who have a great deal of linen and who want it to be extremely white, send it to be laundered in Holland, where the water, filtered by the dunes, is perfectly soft and clear," Macquer, *Dictionnaire des arts et métiers*, vol. 1, p. 272.

147 "Bordeaux merchants send their dirty linen to San Domingo, just as they have their shirts made in Curaçao," *Mémoires de M. le comte de Vaublanc* (Paris, 1857), cited in Franklin, *Dictionnaire historique*, pp. 85–86.

148 *Supplément à L'Encyclopédie*, vol. 1, p. 908.

149 Bibliothèque Nationale, Cabinet des Estampes, Réserve, Lb. 34, J.-J. Lequeu, *Lettre sur le beau savonnage, qu'on pourroit appeller savonnement à Paris, Adressée aux Mères de famille* (Paris, an 2, 1793–94), p. 3. Roche (*La culture des apparences*, pp. 371, 376) is the first to have consulted this unpublished treatise. On Lequeu, see Philippe Duboy, *Lequeu: An Architectural Enigma* (London, 1986), and, most recently, Werner Szambien, "L'inventaire après décès de Jean-

Jacques Lequeu," *Revue de l'Art* (1990), pp. 104-107 (the *Lettre sur le beau savonnage* does not appear among the manuscripts listed in this inventory).

150 Lequeu, *Lettre sur le beau savonnage*, pp. 6-7.

151 Jean-Joseph Vadé, *Lettres de la Grenouillère entre M. Jerosme Dubois, pêcheur du Gros-Caillou, et Mlle Nanette Dubut, blanchisseuse de linge fin* (Paris, 1756), quoted in *Poésies et lettres facétieuses de Joseph Vadé, avec une notice bio-bibliographique*, Georges Lecocq, ed. (Paris, 1879), p. 115.

152 For a sampling of laundresses in Boucher's oeuvre, which does not claim to be exhaustive, see Jean-Richard, *L'Oeuvre gravé de Boucher*, nos. 32, 272, 634, 637, 638, 736, 767, and Alexandre Ananoff and Daniel Wildenstein, *François Boucher*, 2 vols. (Lausanne and Paris, 1976), nos. 56, 167, 220, 250, 259, 381, 458, 464, 505, 508, 510, 532, 585, 586, 587, 608, 634, 635, 655.

153 For the most recent discussion of this celebrated painting, with references to previous literature, see Rand, *Intimate Encounters*, pp. 135-137, and Jennifer Milam, "Fragonard and the Blindman's Game: Interpreting representations of Blindman's Buff," *Art History* 21 (March 1998), pp. 1-25. To the best of my knowledge, no one has previously commented on the profession of Fragonard's female protagonist.

154 For Fragonard's laundresses, see Jean-Pierre Cuzin, *Jean-Honoré Fragonard, Vie et oeuvre* (Fribourg, 1987), nos. 61, 62, 71-75, 83, and Pierre Rosenberg, *Fragonard*, exh. cat. (Paris, Grand Palais, and New York, Metropolitan Museum of Art, 1987-1988), pp. 88-93. For the ubiquitous laundress in Robert's paintings and drawings, see, in the absence of a comprehensive catalogue,

Victor Carlson, *Hubert Robert, Drawings and Watercolors*, exh. cat. (Washington, D.C., National Gallery of Art, 1978), nos. 20, 28, 31, 39, 41, 47, 49, 51, and Pierre Rosenberg and Jean-Pierre Cuzin, *J. H. Fragonard e H. Robert a Roma*, exh. cat. (Rome, Villa Medici, 1990-91), nos. 15, 21, 22, 30, 52, 53, 55, 83, 118, 139, 152. Most recently, the subject of laundresses has been addressed in Donna L. Wiley, "*Le grand point est de plaire*: Essays on and Around the Work of Hubert Robert," unpublished Ph.D. dissertation (Bryn Mawr College, 1999).

155 John Grand-Carteret, *Les Almanachs français* (Paris, 1896), pp. 74-76.

156 "A cet emploi, le bon Homère / Met ses Princesses en leur train; / L'usage aujourd'hui bien contraire / Ne peut fournir même un quatrain." Odysseus's meeting with Nausicaa is recounted in Homer's *Odyssey*, book 6.

157 The best introduction to the *genre poissard* as a theatrical form remains A. P. Moore, *The Genre Poissard and the French Stage* (New York, 1935). See also Mark Ledbury, "Intimate Dramas: Genre Painting and New Theater in Eighteenth-Century France," in Rand, *Intimate Encounters*, pp. 49-67.

158 Moore, *Genre Poissard*, pp. 101-103, and Robert M. Isherwood, *Farce and Fantasy* (New York and Oxford, 1986), pp. 117-118. While an interest in popular types and working-class dialect can be traced back to the seventeenth-century Caquets and Mazarinades, the *genre poissard* was promoted to center stage in the 1740s as part of Monnet's reform of the fair theaters and the Opéra-Comique. In this sense, Favart's pastorals and Vadé's *poissards* were two sides of the same coin: part of the comic, lesser theater

which exploited vernacular and "realistic" language and situations, and finally infiltrated "high art" in the paintings of Boucher and Greuze. The relationship between the popular theatre and Boucher's pastorals has been studied by Alastair Laing, "Boucher et la pastorale peinte," *Revue de l'Art* (1986), pp. 55-64. The importance of *poissard* subjects in Greuze's early Parisian production has not received the attention it deserves, although Ledbury makes suggestive observations on the "collaboration and mutual inspiration of alternative theater and genre painting" in the 1760s; see "Intimate Dramas" in *Intimate Encounters*, pp. 57-64.

159 For an eloquent demonstration of how this "cross-fertilization between high and low" informs Watteau's art, see Thomas E. Crow, *Painters and Public Life in Eighteenth-Century Paris* (New Haven and London, 1985), pp. 67-74.

160 See, most recently, Vincent Milliot, *Les cris de Paris ou le Peuple travesti* (Paris, 1995), pp. 105-121.

161 Conisbee, *Chardin*, pp. 124-126.

162 Crow, *Painter and Public Life*, pp. 53-55; Moore, *Genre Poissard*, pp. 62-92, passim.

163 La Harpe in *Correspondance Littéraire*, vol. 4, p. 27 (August 1758).

164 Isherwood, *Farce and Fantasy*, pp. 110-119.

165 For a good account of Vadé's literary contribution, see Pierre Frantz, "Travestis poissards," *Revue des Sciences Humaines*, 61 (April-June 1983), pp. 7-20.

166 For the "Lettres de la Grenouillère," I have consulted a nineteenth-century edition of Vadé's works; see *Poésies et lettres facétieuses de Joseph Vadé*, pp. 101-127.

167 See the various editions listed in the Bibliothèque Nationale's *Catalogue général des livres imprimés*, vol. 198, cols. 26-29, 41-42 (1756-1760).

168 *Explication des Peintures, Sculptures, et Gravures de MM. de l'Académie Royale* (Paris, 1753), no. 11, "Sujet tiré d'un petit ouvrage en vers de M. Vadé"; the whereabouts of this painting are unknown. Diderot (*Salons*, "Salon de 1763," vol. 1, p. 206) referred to Jeaurat, "formerly the Vadé of painting," as one "who was familiar with scenes from the place Maubert and Les Halles."

169 Jeaurat remains more or less unstudied; for a convenient biography and summary of previous bibliography see Marie-Catherine Sahut's entry in *Diderot et l'Art*, pp. 280-283.

170 Geneviève Bollème, ed., *La Bibliothèque Bleue: littérature populaire en France du XVIIe au XIXe siècle* (Paris, 1971), pp. 107-110. The earliest edition of this tale is 1713.

171 *Memoires et Journal de J.-G. Wille*, vol. 1, p. 124.

172 Diderot, *Salons*, "Salon de 1761," vol. 1, p. 144. It should be noted that Diderot had visited the Salon of 1761 in the company of the abbé Galiani, the Italian diplomat and economist, who was also a close friend and correspondent of Mme d'Epinay. Louise-Florence-Petronille-Tardieu d'Esclavelles (1726-1783) had married La Live de Jully's notoriously profligate older brother, Denis Louis de La Live d'Epinay, in December 1745. On this circle, see Francis Steegmuller, *A Woman, a Man, and Two Kingdoms* (New York, 1991).

173 Diderot, *Salons*, "Salon de 1761," vol. 1, p. 144.

174 Even the Comédie Italienne began to introduce *poissard* themes into its repertory. In February 1761 it presented *Les Caquets* (*The Prattlers*) by Luigi Riccoboni, "adapté aux moeurs et aux caractères d'une Classe du Peuple François, entre la haute Bourgeoisie et le dernier État populaire." The play included such stock *poissard* characters as boatmen, seamstresses, and second-hand clothes sellers ("revendeuses"), and opened with the signing of a marriage contract; see *Mercure de France* (March 1761), p. 194; idem (April 1761), pp. 164-165.

175 Edmond and Jules de Goncourt, *French Eighteenth-Century Painters*, Robin Ironside, trans. (Ithaca, New York, 1981), pp. 221-222. The chapter on Greuze first appeared in the Goncourts' *L'Art du XVIIIe siècle*, 2 vols. (Paris, 1880), vol. 1, pp. 289-360.

176 A point well made by Rand in his discussion of the Fogg replica; see *Intimate Encounters*, p. 158.

177 See Fairchilds, *Domestic Enemies*, pp. 174-185; Maza, *Servants and Masters*, pp. 109-113, 129-133.

178 Count Anthony Hamilton, "Lettre à Madame La Princesse d'Angleterre" (circa 1700), cited in Roger Lecotté, "Folklore des blanchisseurs parisiens," *Bulletin folklorique de l'Île de France* (January-March 1955), p. 706.

179 Marivaux, *Le Paysan parvenu* (Paris, Garnier-Flammarion, 1965), p. 44.

180 On the crime of *rapt de séduction*, see Fairchilds, *Domestic Enemies*, pp. 174-175.

181 Isherwood, *Farce and Fantasy*, p. 95.

182 Camille Piton, *Paris sous Louis XV: Rapports des Inspecteurs de Police au Roi* (Paris, 1908-14), vol. 1, pp. 141-145, 202-204. Ironically, La Live de Jully himself appears in these pages, as one of the clients of "la demoiselle de Senneville . . . américaine," with whom he had been involved in 1758, paying ten louis (240 francs) for each nocturnal visit (April 4, 1760).

183 Fairchilds, *Domestic Enemies*, p. 75.

184 Restif de la Bretonne, *Les Nuits de Paris*, Daniel Baruch, ed. (Paris, 1990), p. 656. This compendium was first published in twelve volumes in 1788; *Le secret des blanchisseuses* appears in volume 1, no. 18.

185 Lépicié's *Le Lever de Fanchon* 1773 is catalogued in Oursel, *Au temps de Watteau, Fragonard, et Chardin*, pp. 122-123; on Touzé, who had been a student of Greuze's, see Eric Zafran's entry in *The Forsyth Wickes Collection* (Boston, Museum of Fine Arts, 1992), pp. 144-145.

186 Diderot, *Essais sur la peinture; Salons de 1759, 1761, 1763*, Gita May and Jacques Chouillet, eds. (Paris, 1984), p. 156. This is the first edition to use Diderot's autograph manuscript of the Salon de 1761, recently acquired by the Bibliothèque Nationale, but not available to Seznec and Adhémar, who based their edition on a contemporary version that circulated as part of the *Correspondance Littéraire* (Bibliothèque Nationale, fonds Firmiani).

187 Edmond and Jules de Goncourt, *French Eighteenth-Century Painters*, p. 246.

188 Ibid., p. 247.

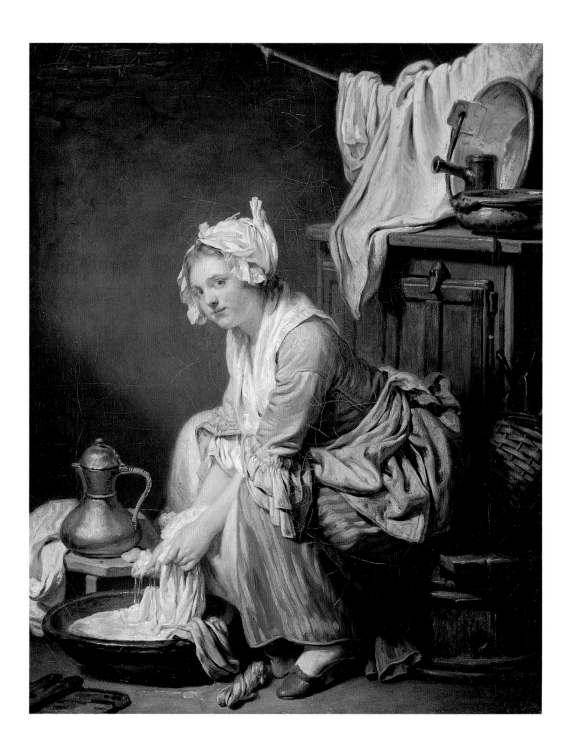

ACKNOWLEDGMENTS

I wish to thank Andrea Belloli, former editor-in-chief of the Publications Department of the J. Paul Getty Museum, who commissioned me to write this book, and Mark Greenberg, Managing Editor, who made sure that I did so. The staff of the Paintings Department at the Getty Museum and their colleagues in the Paintings Conservation Department were unfailingly helpful and generous both of their time and their resources. For her careful editing of my manuscript and his elegant design of this book, I wish to thank Mollie Holtman and Jeffrey Cohen.

Edgar Munhall, doyen of Greuze studies, saved me from several errors, and Aileen Ribeiro was most patient in answering my questions on eighteenth-century servants' dress. In Paris, I was graciously assisted by Charlotte Lacour-Veyranne, Christophe Léribaut, and Maxime Préault. Alan Wintermute encouraged me during the writing of this book and gave the manuscript a careful and critical reading; thanks are also due to Joseph Baillio, Bernadette Fort, and Catherine Lafarge.

My greatest thanks go to the staff at the National Gallery of Canada, without whose collaboration this book would never have seen the light of day. Above all I am grateful to John Collins for his thorough and imaginative research, but I would also like to mention Meva Hockley, Charles Hupé, Anna Kindl, Leah McFectors, Michael Pantazzi, Penny Sullivan, and Maija Vilcins. A special thank you, as always, to Pauline Labelle and Arline Burwash.